TREES

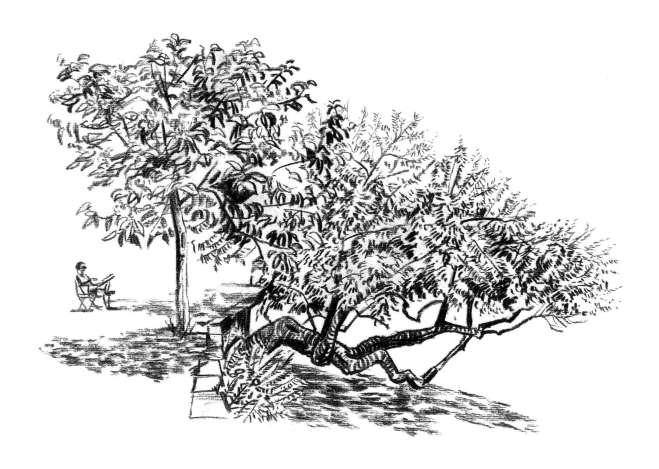

Roger Hutchins

HarperCollinsPublishers

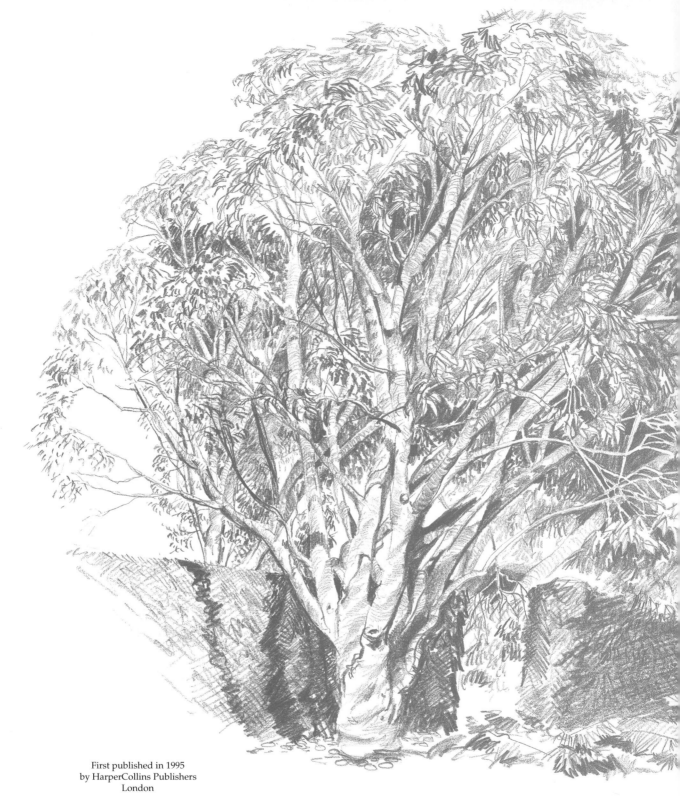

First published in 1995
by HarperCollins Publishers
London

© HarperCollins Publishers 1995

Text Consultant: Tessa Rose
Editor: Diana Craig
Art Director: Pedro Prá-Lopez, Kingfisher Design Services
DTP/Typesetting: Frances Prá-Lopez, Kingfisher Design Services
Contributing artists: Sylvia Bennion, David Hackman,
Deborah Maizels, Diana Mayo, James Robins, Halli Verrinder

A catalogue record for this book is available from the British Library

ISBN 0 00 412756 0

Produced by HarperCollins Hong Kong

CONTENTS

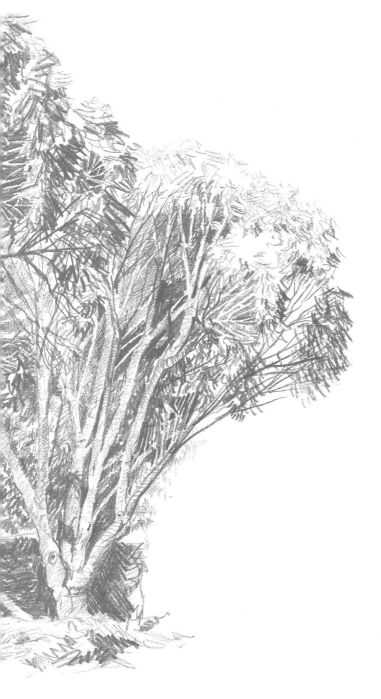

Introduction

Trees are among nature's loveliest gifts to our landscape. The many varieties of deciduous and coniferous trees offer us endless possibilities for artistic expression. Leaf shapes, bark textures and fruits alter depending upon type, and a majestic horse chestnut we have come to know in its summer splendour will present us with fresh aspects of itself in spring or autumn. The light conditions are also among the infinite variables we can add to the equation.

If tackled in all their complexity and diversity, trees can demand a wide range of skills of the artist. Paradoxically, simple rules govern the way we draw trees, and whether you choose a slender rowan or a venerable oak as a subject, you'll find the same growth structure in each. Mastery of the simple rules shared with you during the course of this book will provide a solid technique, enabling further exploration along avenues of your own choosing.

I shall also provide guidance on important aesthetic aspects, such as selecting a subject and deciding upon a centre of interest. Analyzing what one has drawn is an invaluable discipline, because we learn only by seeing our mistakes, by, for example, discovering what we should have left out or, conversely, left in, and knowing when to stop work.

Which medium to use is always a personal choice, and can take time to settle. Don't worry if you struggle at first: you're bound to until you discover the medium's character or find the one (or ones) that best suits your temperament or abilities. I would suggest, though, that you use only one medium at a time.

The challenge and enjoyment of drawing trees is immense. If this book succeeds in enabling you to share in these experiences, I shall consider this book to have been a worthwhile endeavour.

Roger Hutchins

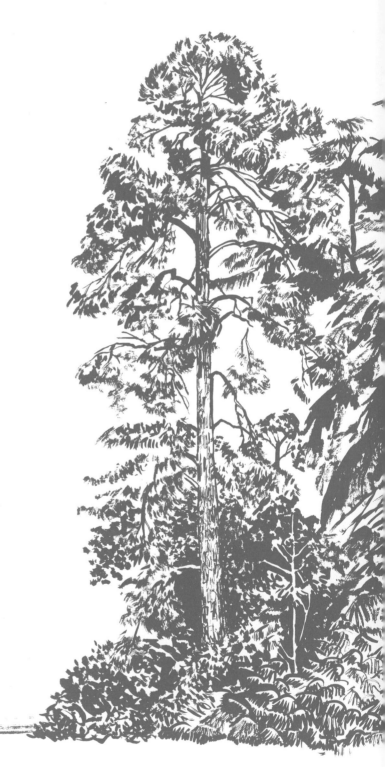

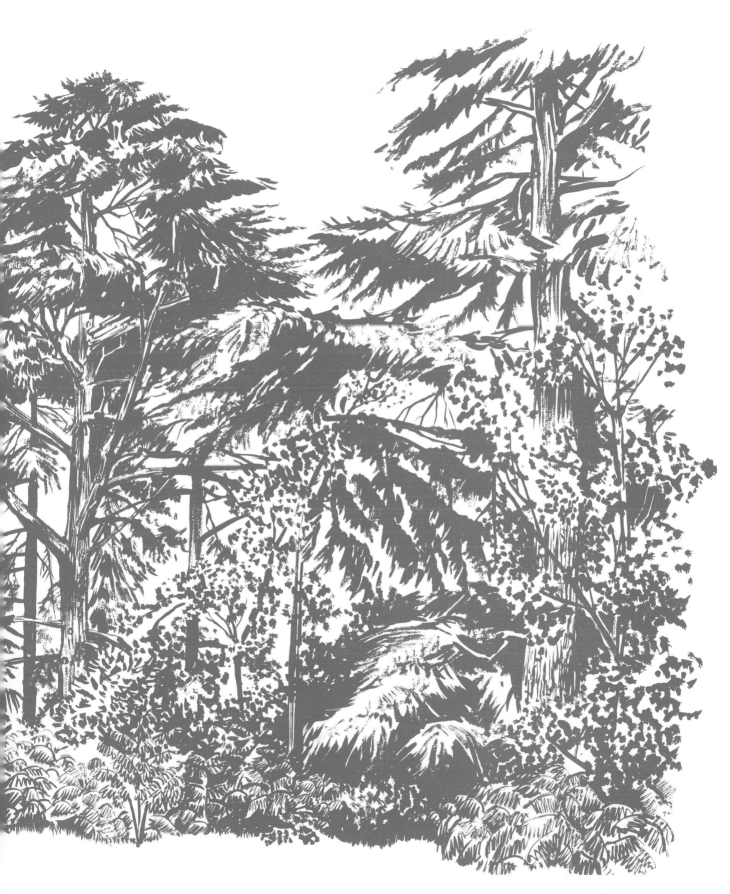

Tools and Equipment

The beginner may be daunted by the enormous range of art materials on offer. Each type of tool or medium has been developed for a particular purpose to create its own effect. To begin with, use materials that are familiar to you.

Discovering what suits your way of working will come with time and after a period of experimentation. Whatever you decide upon, though, it is always a good idea to buy the best you can afford if you want good results.

Pencils

The humble pencil is potentially the most subtle drawing implement available to us. Drawing pencils range in hardness from the softest, 9B, to the ultra-hard 9H. The best all-round pencil for sketching is the 2B, which gives a slightly wider variety of mark and tone than the middle-of-the-range HB. Propelling and clutch pencils give an even weight of line and are available with a variety of 'lead' types. Coloured pencils, flat strip carpenters' pencils and water-soluble pencils offer exciting variations in the way that they can be used. Don't be afraid of smudging areas, or erasing marks to change their weight or to remove them altogether.

This vigorous drawing *(below)* was made with an HB leaded 0.5mm propelling pencil on textured watercolour paper. The difficulty of creating broad areas of tone was overcome by hatching.

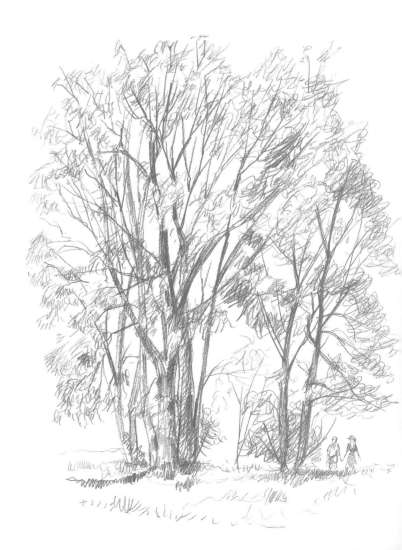

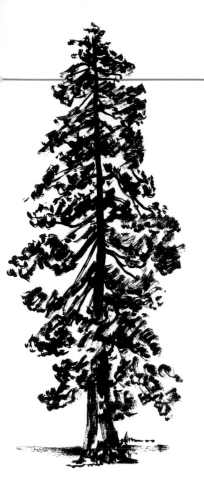

A felt-tipped brush pen was used to produce this Wellingtonia, a type of sequoia from California *(left)*. The long, pointed tip of this pen resembles and behaves in the same way as a conventional brush.

Pens

The ballpoint moves smoothly over paper and is good for quick sketches, but varying the weight of line is difficult and 'scribbling' to produce darker areas can be messy. Felt- and fibre-tipped pens come in a wide range of ink colours and line widths; you may want to combine a fine one for detail with a thicker one for tone, perhaps in different colours. Fountain and dip pens can produce lines of varying thickness, while technical pens offer consistent width and are particularly useful for working over a pencil drawing.

The controlled stippling evident here *(right)* was achieved with a technical pen; the higher the density of the stippling, or dots, the darker the tone.

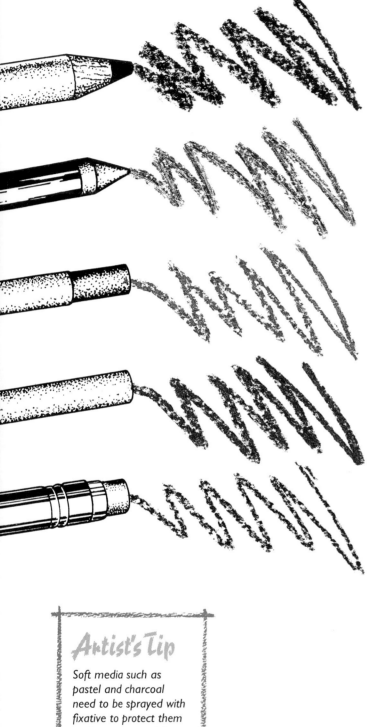

Chalks and pastels

These materials can produce a variety of textures and tones and can easily be smudged and blended. Because they are soft materials, neither is ideal for detailed studies requiring controlled hatching or stippling. They come into their own when used in large, free-flowing drawings. Use them on their sides, too, for filling in large areas.

Pastels come in a vast range of colours and in both pencil and stick form. The fact that you can buy them singly or in sets gives you the choice of either taking the plunge and buying a whole range or starting with just a few while you discover whether they suit you. They work well when used on top of watercolour.

Conté crayon

This type of crayon has a greasy texture which makes it harder and less prone to crumbling than pastels. The crisp marks that are the hallmark of the conté crayon can easily be smudged to enable blending.

Artist's Tip

Soft media such as pastel and charcoal need to be sprayed with fixative to protect them and prevent smudging. A kneadable putty eraser can be moulded to a point for stippling.

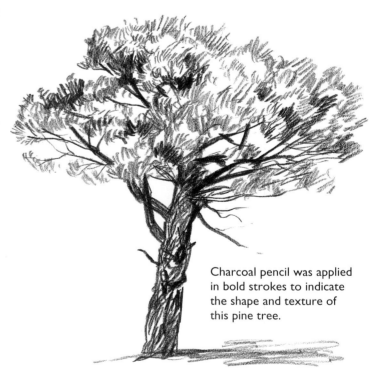

Charcoal pencil was applied in bold strokes to indicate the shape and texture of this pine tree.

You need to take a bold approach to drawing if you are to get the best out of this particular medium. The main advantage of charcoal is that it enables you to cover large areas of paper quickly. In its pencil form it can be used like an ordinary lead pencil. With stick charcoal you can use both the tip and the side, which is ideal for large-scale drawings but, compared with the pencil form, can be a bit messy to use.

Because charcoal smudges very easily, and rarely to the benefit of the chosen subject, one of the main points to remember when working with it is purely logistical – not to rest your hand on the drawing! Marks drawn with bold movements of the arm and wrist give the best results. A putty eraser can be used to remove marks or to create highlights. However, this righter of wrongs should only be used sparingly and in small areas of the drawing.

Wax crayons and oil pastels

Although both these types of media are available in a wide range of colours, they are not ideal for the novice. Neither type combines well with other dry media and both are very difficult to erase, so mistakes can prove costly in time, effort and temper. My advice would be to experiment thoroughly first to find out just what you can and can't do with them.

In skilled hands wax crayons can be effective tools but overworking is an ever-present danger even for the experienced artist. Oil pastels pose slightly less of a challenge, being easier to work with generally.

Charcoal

This material is made from willow twigs which have been charred in an airless atmosphere. Charcoal's primary purpose is not as a drawing medium but as a tool for making preliminary sketches at the initial stage in a painting.

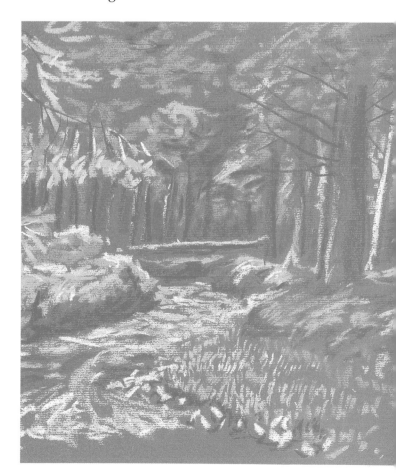

The foliage and grass in this woodland scene were rendered with broken pastel strokes, using the tip and the edge of the pastel, on a dark paper background.

Brushes

Brushes vary so widely in size, shape and quality that settling on which type to buy is not an easy decision. I use large, good-quality brushes, usually a round No. 4 or No. 6, which will produce a generous wash and a fine line. A flat-tipped brush will give a flat wash – ideal for skies – and can be used to render tree trunks. Fan-shaped brushes are used for blending colours; I use this type for creating shadows with dappled effects and for foliage.

Provided you look after it, a fine-quality brush – say, of sable, which is used to make the best brushes – will easily outlast its cheaper counterparts. However, modern synthetic brushes are almost as good in quality, and are also cheaper and more robust.

3 For an even layer of strong watercolour, add darker washes to a light wash while still wet.

4 To prevent colours 'bleeding' together, let the first layer dry before adding the next.

5 For a soft, blurry effect, paint watercolour on to paper that has been slightly dampened.

6 Ink or concentrated watercolour on damp paper will spread into swirls and blotches.

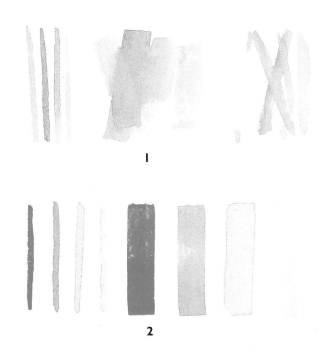

1 These brush marks were made with *(from left to right)* a small, pointed brush; a flat brush; a large, pointed brush.

2 Watercolour tone can be progressively reduced by adding more water, as shown by these strokes using different dilutions.

Wet media

Inks are easily mixed and come in brilliant colours. They can be used in several ways: applied with a pen as a line drawing or used with a brush to produce a wash. These two methods can also be combined to create a line-and-wash drawing. First, do your drawing, then wait until it is completely dry before adding the colour wash; if you use waterproof ink, the line will not dissolve, and will remain clean and sharp. It is a good idea to keep a brush just for using with ink. Some inks, especially waterproof ones, will quickly damage a brush if it is not thoroughly washed immediately after use.

Watercolour is a water-based paint. It can be purchased in tubes, small blocks or pans, or in

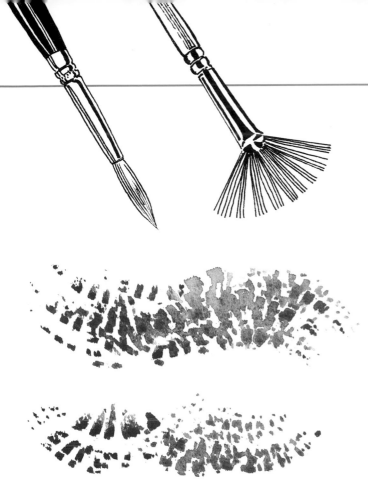

A multi-purpose round-tip brush *(far left)*; and a fan-shaped brush for blending colours *(left)*, which can be used to create a pattern suggestive of leaves and dappled shadow *(below left)*.

In this leafy drawing *(below)*, a fan brush was used for blocks of foliage, a No. 6 round brush for foreground leaves and trunks, and a narrow, flat brush for the chestnut leaves.

Artist's Tip

Bristle differs from hair in two ways: instead of tapering to a point like natural hair, it splits into a forked end and it has exceptional spring. These qualities make it particularly suited to dry-brush and stipple work.

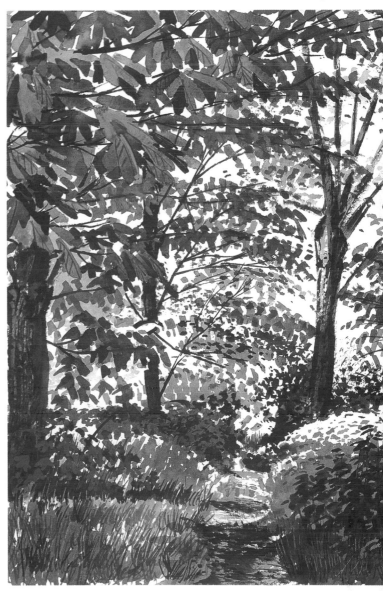

concentrated liquid form. Used directly, its effect can be strong and vibrant. Conversely, when diluted with water it can be used to produce subtle, transparent tones. Highlights can be created by leaving areas of the white paper blank. Watercolour can be added to a drawing in waterproof ink or oil pastel with no danger of the media merging into an unpalatable mess because the watercolour will not adhere to either the ink or the pastel.

Gouache is also water-based, but is more versatile, however. It can be applied thickly to mask underlying pencil sketching or diluted to create transparent areas.

Acrylic paint is thick and looks like oil paint although it is, in fact, water-soluble. It is quick-drying and good for building up layers. It can also be diluted to create a watercolour effect.

For wet media work, you will require a palette for mixing paint and two jam-jars – or ideally, anti-spill pots – containing water, one for mixing colour and the other for cleaning your brushes.

Newsprint is very inexpensive, which makes it good for practising and rough sketching.

Tracing paper is semi-transparent, so that you can lay it over other images and trace them.

Stationery paper, usually available in one size, has a hard, smooth surface that works well with pen.

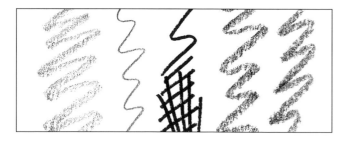

Cartridge paper usually has a slightly textured surface, and is one of the most versatile surfaces.

Surfaces to draw on

The character of your drawing will be determined as much by the surface on which you work as by the implement you use. Your choice will depend largely on the effect you want to achieve with your subject. The question to ask yourself is: 'How will the texture of this particular paper affect my drawing?' Some media work best on a particular type of paper or board, and with experience you will discover what surface suits your subject and style.

Don't be afraid to experiment with as many different combinations of media and surface as possible. White conté, for example, works better on black or dark paper than light or white paper, while dip-pens tend to snag on rough-textured paper and splatter. As a general rule, pen, wash and detailed pencil work are best done on smooth papers, while bold, dark pencil, charcoal and crayon are suited to rougher surfaces. Pastels need a slightly rough surface: a tinted pastel paper is ideal.

Types of surface

You may find the cost of some papers prohibitive (hand-made, for example) but there are many modestly priced types available. Do not overlook cheap, everyday papers, either. Brown wrapping paper, stationery paper or plain newsprint paper, for example, all provide a robust working surface for drawing.

Tracing paper can be extremely useful for planning a composition. Sheets of tracing paper with individual drawings on each can be laid over one another to work out a composition; layout paper can also be used similarly.

Cartridge paper is available in rolls, sheets or pads, and in either cream or white. It is ideal for sketching and drawing in pencil or pen and for light applications of colour. For a very smooth, dense surface, try a hard-surface cartridge paper.

Ingres paper comes in sheets or pads and in a range of colours. It is ideal for use with pastels, conté crayons and charcoal.

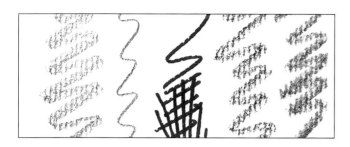

Ingres paper, in various colours and with a lightly ridged surface, is ideal for pastel and charcoal.

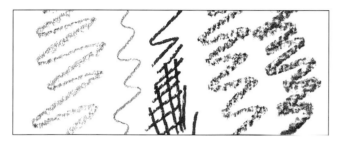

Watercolour paper is thick and absorbent, and has a rough surface. It is good for wet media.

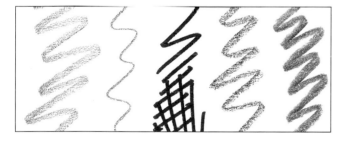

Bristol board is stiff and has a smooth finish that makes it a good surface for pen drawings.

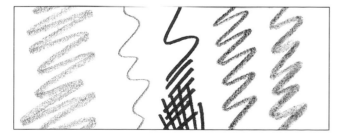

Layout paper is a semi-opaque, lightweight paper that is very suitable for pen or pencil drawings.

Watercolour paper may be hand-made or machine-made and comes in three surface textures: *rough*, *not* surface, and *hot-pressed* or *fine*. Tough, absorbent and acid-free, it will not turn brown if exposed to daylight for long periods and will not buckle when dampened.

Bristol board provides an extra smooth surface suitable for ink-drawing.

For outdoor drawing, use a sketching block, book or pad.

Ingres paper can give surface texture. In this example *(below)* I used white conté to draw the tree shape and provide highlights on the black paper.

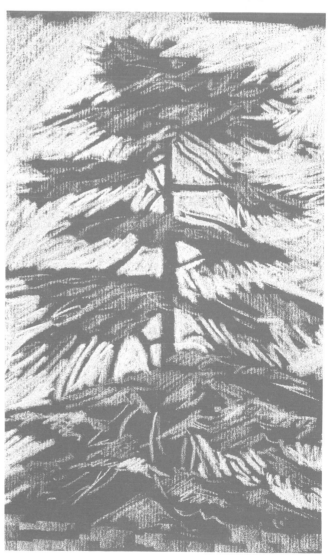

Choosing the Right Medium

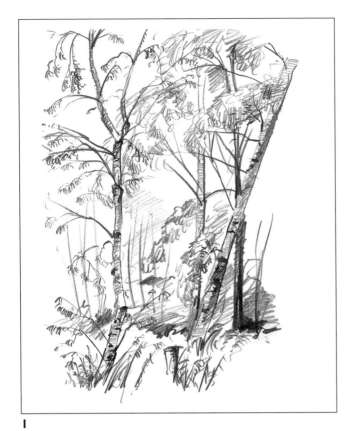

1

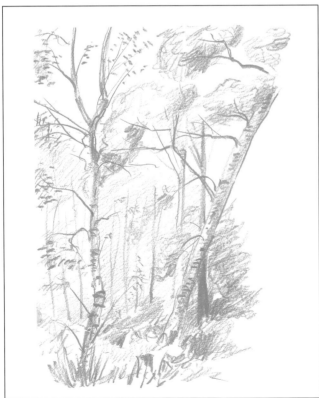

2

To show you what can be achieved with different combinations of media and surfaces, I have completed six drawings of the same view.

In the first drawing, pencil on smooth cartridge gives a representation of medium sharpness. The smoothness of the paper limited me to a straightforward, literal treatment of the subject but did not allow much depth or differentiation. Compare this with the looser, more impressionistic style created by the softer pencil and texture of the paper in the next drawing. Note how the more generalized treatment gives an idea of depth and a more unified composition.

The pen-and-ink drawing is the most sharply defined of the six and as a result the most impersonal. The fine leaf work suggests delicacy, but depth can only be achieved by energetic cross-hatching.

Using watercolour, in the fourth drawing, allows you to suggest more than you actually show: dotting with the pointed end of the brush gives an idea of leaf shape; the background wash provides an instant definition of depth, as does the foreground detail. The large areas of paper left blank allow the trees to stand out and hint at a sky beyond and above.

In the fifth drawing, I used the tip of a charcoal stick for the leaves and its side for the background, smudging the latter to give an impression of depth. The charcoal also allowed me to differentiate between the trees. The heavy texture of the paper helps draw the eye in, while in the sixth drawing, the underlying darkness of the paper helps to create mood and depth and also provides the structure of the tree trunks. Soft pastel creates the background and highlights.

1 Pencil on smooth cartridge paper
2 Soft pencil on watercolour paper
3 Pen-and-ink on light layout paper

4 Watercolour on watercolour paper
5 Charcoal on white Ingres paper
6 Soft pastel on dark Ingres paper

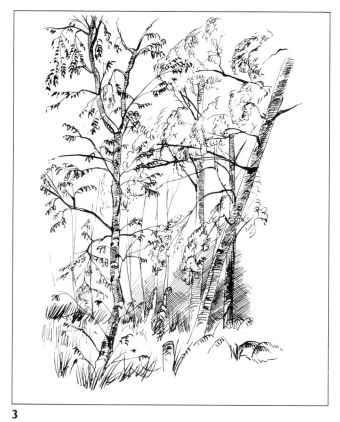

3

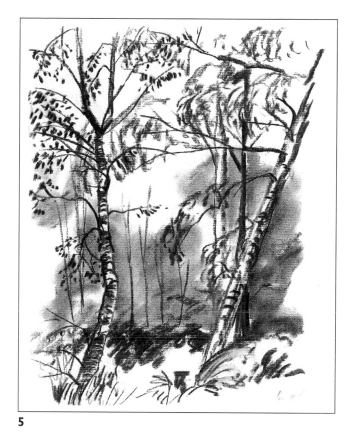

5

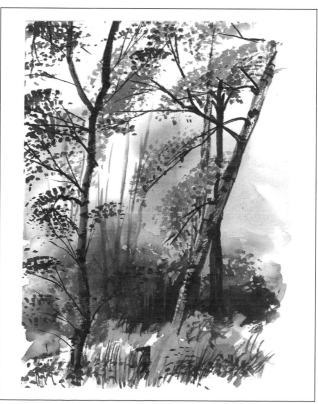

4

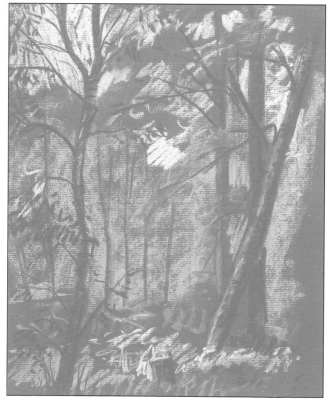

6

Looking at Tree Shapes

It is not necessary to know the name of the tree you decide to draw. However, an understanding of tree types, their habits and how they change through the seasons can add to your enjoyment of the picture-making process and your appreciation of the environment in which you are working. I would recommend that you add a pocket guide to trees to your drawing kit to help you identify trees in all seasons. (I use the *Collins Gem Guide to Trees*.)

I have selected an assortment of tree types to show you the range of trunk and branch structures, leaf shapes and growth habits you are likely to encounter.

Tree types

There are two main tree types: conifers and broad-leaved. The conifer has a tall, central trunk with a regular arrangement of small or medium-sized branches. These radiate outwards along the length of the tree, and often sweep downwards. The conifer sheds its needle-shaped leaves gradually throughout the year, and shows little change as the seasons pass.

To the untrained eye, broad-leaved trees can look similar to each other when in full leaf and can either be deciduous, like the English oak, or evergreen. However, the overwhelming majority of broad leaves are deciduous. Any tree whose leaves are basically flat, as distinct from being needle-shaped, may be defined as broad leaved. The Holm oak is a broad-leaf evergreen which retains its leaves all year and like the conifer sheds worn out leaves gradually. It is a very densely crowned tree, and has distinctive narrow dark green leaves.

Deciduous broad leaves, in contrast, shed all their leaves in autumn in order to conserve the energy they have built up during the summer to produce the following year's leaf growth. The new leaves appear in late spring.

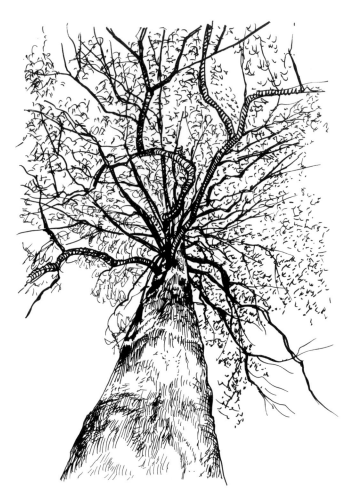

Looking up the tall trunk of a large conifer *(above)*. In this type, the many branches typically grow out of the trunk in a regular pattern and along most of its length.

A view from beneath a typical deciduous tree, in this instance a beech *(below)*. In contrast to the evergreen conifer, much more sky is visible because of the absence of leaves.

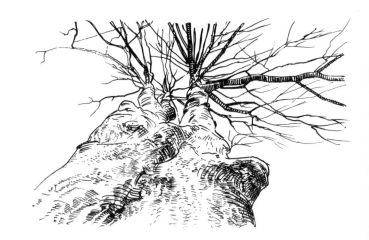

Deciduous tree shapes

The English oak is a large, often irregularly shaped tree characterized by massive dog-leg branches and finely cracked, ridged bark.

The beech is a tall, impressive tree with smooth, grey bark which is often discoloured green by algae. In summer, it has a dense canopy which casts a deep shadow and through which little or no sky may be visible. In winter, the structure of the tree is more visible. Its large, upward-growing branches can be seen separating from the trunk comparatively low down and dividing further into boughs and smaller branches.

The Holm oak *(above)* is a broad-leaf, but it is evergreen rather than deciduous. This ubiquitous tree is distinguished by its dense crown and narrow, dark-green leaves.

Twisting branches and ridged bark typify the English oak, pictured here in winter *(right)* and summer *(far right)*.

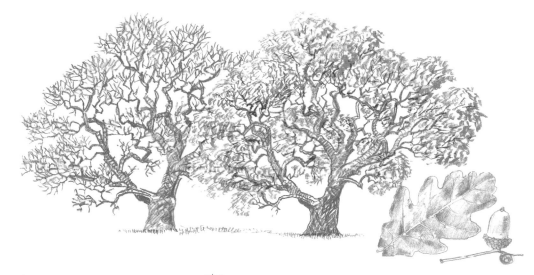

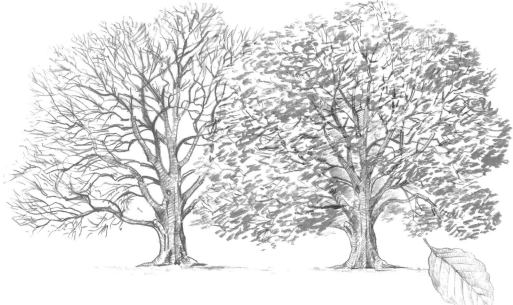

The beech in its winter *(far left)* and summer guises *(left)*. Tall and impressive with smooth grey bark, it casts a deep shadow beneath its canopy in summer.

The weeping willow is perhaps the easiest of all trees to identify. It has long, curved, drooping shoots which hang from bright yellow twigs and reach to the ground.

The ash has distinctive pinnate leaves and a long, fairly straight trunk. It comes into leaf relatively late in the season. Its bark is pale grey and very smooth in young trees.

The silver birch is very common and easy to identify. Fast-growing and short-lived, it has delicate leaves which hang down from upward-growing branches, and a distinctive white, scaly bark.

The horse chestnut is a tall, upright species which originated in the Balkans. An early leafer, it has very distinctive leaves, flowers and fruit (conkers). This is an ideal subject for a beginner.

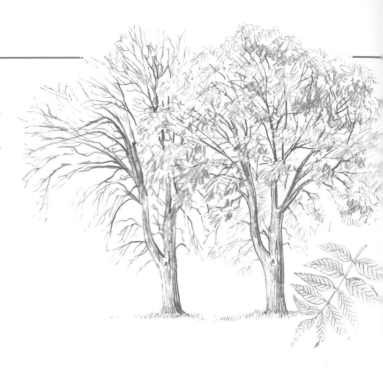

The ash in summer *(above right)* and winter *(above left)*. Its summer canopy is not as dense as that of the horse chestnut opposite.

The shapes of the trunk and main branches are clearly visible. The pinnate shape of the leaf allows light through the canopy.

The tree has dense tiers of foliage that do not demand painstaking attention to detail or precise drawing skills.

The Lombardy poplar has a distinctive shape, and is nearly always found in groups as it is often planted as a windbreak. Its tall, slim branching outline makes it an easy tree to depict. A hybrid of the black poplar, it is always male.

The weeping willow in its winter guise *(left)*. I have used gestural marks to give a feeling of movement. Back lighting allows us to see the branch structure of this impressive specimen.

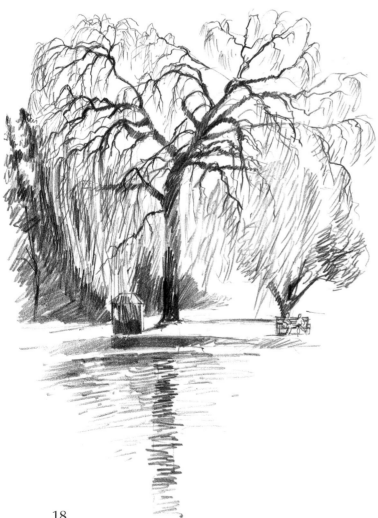

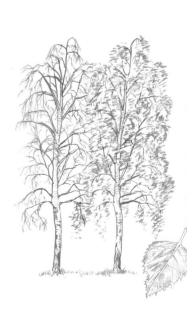

A silver birch in winter *(right)* and summer *(far right)*. In the latter, I have tried to convey the rippling effect that is so characteristic of the tree in a gentle summer breeze.

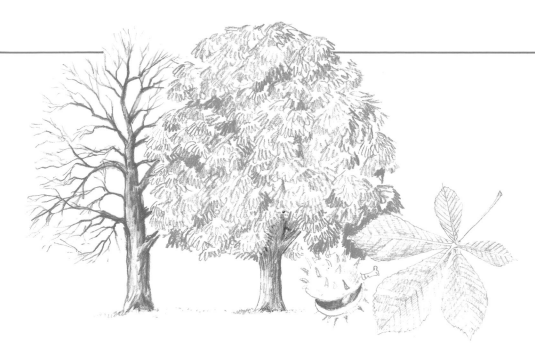

The horse chestnut in winter *(far left)* and summer *(left)*. The tree's large leaves provide a dense canopy which can be easily generalized using a soft pencil, even by the beginner.

Tree canopy

One of the biggest challenges facing the artist when drawing deciduous trees is how to deal with masses of leaves in a canopy. In spring deciduous trees flower and break into leaf, so gradually building up a canopy. Until this canopy is complete the tree's appearance will undergo constant change. Leaves are a tree's 'solar panels' and they will not function if they are in continuous shade. As each layer of growth leaves is built up, there is some overlap between branches. Any leaves obscured by the new growth and continually in the shade will either have to grow towards the light or die. Although there is variation between individual trees within a species, each species has a distinctive canopy and leaf mass. Familiarizing yourself with the growth habit of a wide range species will be invaluable when you come to draw groups containing a mixture of species.

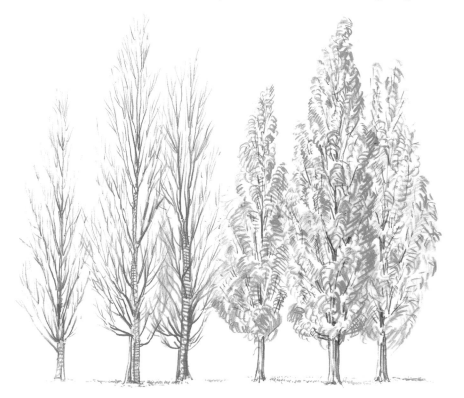

Artist's Tip

Deciduous trees are a dynamic subject for the artist. They are constantly changing. Observe their growth patterns in all seasons in order to really get to know them.

The Lombardy poplar, in winter *(far left)* and summer *(left)*. You will invariably find this species in groups. It presents an easy shape for the beginner to draw in soft pencil.

Conifers

The majority of commercially grown timber is coniferous. This is because deciduous trees are wasteful of resources, protecting their leaves from frost by shedding them in autumn and growing a new set in spring. In contrast, conifers often grow in poor soils or in cold climates with short growing seasons. They have evolved needle-shaped leaves that are better protected against frost and excessive water loss. They also form their seed in scaly cones which give protection against the weather and animals. Conifers are therefore usually found growing together in a plantation and are only planted as individual specimens when grown for ornament. This is a pity for the artist because in a plantation you will generally find that the trees are uniform in species, age and spacing and so lack variety.

Despite the fact that all species share the same leaf form, conifers come in a range of shapes and can offer a real challenge. Your best bet would be to try to visit an arboretum and draw as many species as possible while you are there.

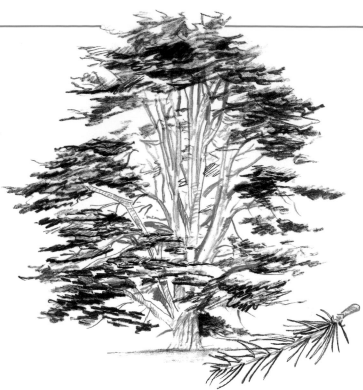

A cedar of Lebanon *(above).* The striking contrast in tone between the trunk and the leaf mass, achieved with pencil and charcoal, gives a realistic, three-dimensional impression of the subject.

The cedar of Lebanon is majestic, serene and multi-layered. It is not the easiest tree for the beginner to draw because there are so many aspects to it, but it provides a worthwhile exercise in depicting spatial arrangement realistically. The dense yet widely spaced layers of foliage never obscure the complex structure beneath. It might be helpful to think of each cedar of Lebanon as a series of Scots pines formed around a central trunk. Each individual branch of a mature specimen of the species can be as large as the average Scots pine. Lower down the tree, the branches form large planes which sweep down to touch the ground. The bark of a mature tree consists of dull brown, scaly ridges separated by wide, deep fissures.

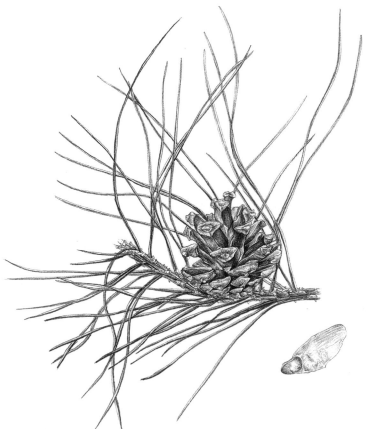

A detail of the needles and a female cone of the Corsican pine *(left).* The contrast between the long, sinuous needles and the tight, hard, multi-edged cone provides an interesting subject, requiring close attention to detail – as well as time and patience!

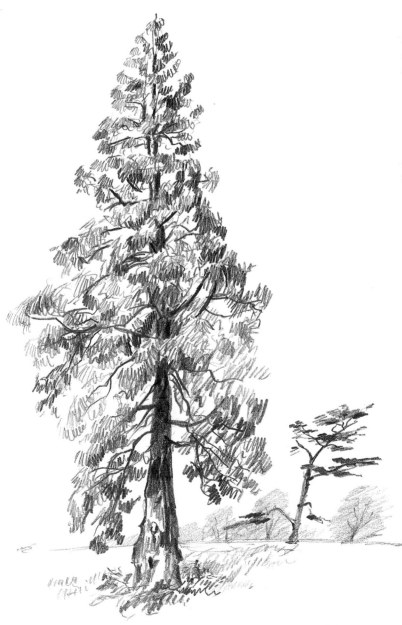

The Corsican pine resembles the Scots pine but has darker bark and longer needles which are grey-green and twisted.

The Norway spruce is a major source of commercial timber. Young examples of the species are often sold as Christmas trees. This type of spruce grows rapidly when young but slows down when it reaches about 20 metres (65 feet) in height. It forms a very regular conical shape and has branches which typically turn up at the tips.

The uniform shape of the Norway spruce *(right)* makes it a fairly easy tree to reproduce. Short strokes in soft pencil define the sweeping structure of the branches, giving an impression of detail with a minimum of effort.

The Scots pine is one of the 80 species of pine tree native to the northern hemisphere. It is distinguished by its short, blue-green needles and pinkish-brown upper bark. The mature tree forms a flat-topped layer as the lower branches become too heavy and gradually fall off. The species is long-lived (about 200 years), so you will come across examples with various branch structures.

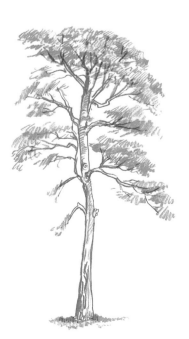

This Scots pine *(left)* is fairly simple to draw as it has so few branches and broadly defined leaf masses.

Densely packed needles characterize conifers. They cast strong shadows as opposed to the dappled light of a deciduous wood. This conifer *(right)* was placed in context in a landscape, with distant trees and a horizon line.

Exotics

In cold climates you will find unusual and exotic tree specimens in parks, gardens, botanical gardens and arboreta. However, to enjoy such varieties in their native habitat, you will have to travel to warmer climes. Discovering exotics in their natural setting will not only introduce you to exciting varieties with different growth patterns, leaves and fruit, but also to an entirely new landscape. If you do not have time to make elaborate drawings on the spot, quick sketches supplemented by photographs will enable you to make finished drawings when you return home.

The chusan palm, a native of China and Japan, has no branches on its trunk but a crown of radiating leaves. These are very distinctive: large and fan-like, they consist of long, sword-shaped segments which form in groups about a metre wide on the ends of long stalks. The bark consists of a mass of hard, brown fibres and woody bases of leaves which have been shed in previous years.

The most difficult aspect of the monkey puzzle tree *(right)* for the artist is its characteristic mass of contorted branches which sprout from the tall, straight trunk. To depict these realistically it is best to avoid making the structure dense by trying to include too many branches.

The Chile pine, also known as the monkey puzzle tree, is slow-growing and often found in gardens where it is planted as a novelty. It has a straight trunk with horizontal, well-spaced, snake-like branches. The tree's strange shape is produced by the wide, spiky needles, which also cover the trunk, growing in layers over each other, like the scales of a fish. The showy, female flowers take two years to ripen into the large, spicy fruit.

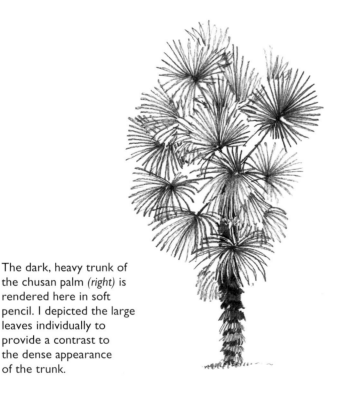

The dark, heavy trunk of the chusan palm *(right)* is rendered here in soft pencil. I depicted the large leaves individually to provide a contrast to the dense appearance of the trunk.

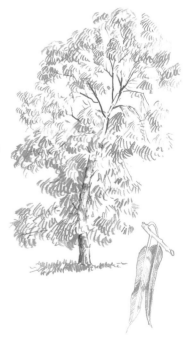

The pendulous shape of the eucalyptus *(right)* can be suggested by short, downward strokes of a soft pencil using variable pressure to give difference in tone.

The eucalyptus is a native of Australia. Once mature, this tall, majestic and fast-growing evergreen is full-domed, irregular and heavily branched. It has pendulous, sickle-shaped leaves, and bark which peels off in strips.

The coconut palm has a tall, slender and frequently leaning trunk supporting a cluster of long, feather-like fronds.

Two washes were used to establish the outer edges of the trunk of this coconut palm. While the washes were still wet, clear water was run between the two lines to 'bleed' them together, creating a graduated effect. Background washes were then added. The fronds and the bark were dry-brushed using a wide (14mm) flat brush. Detail was added with a fine brush.

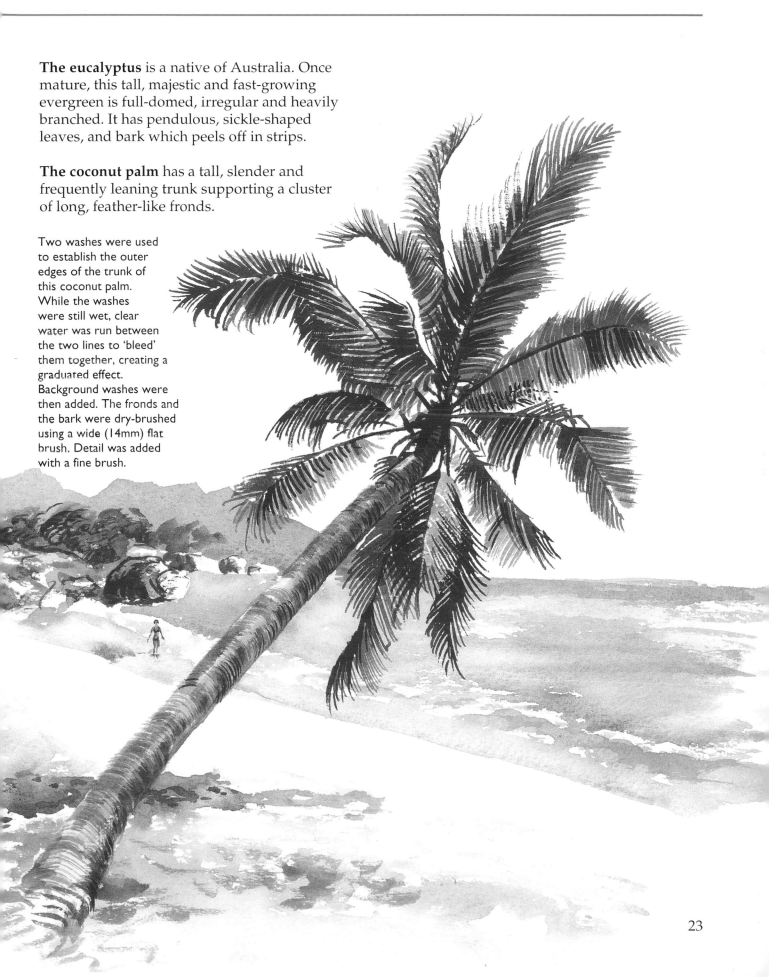

Looking at Detail

Drawing parts of a tree instead of the whole can offer both a refreshing change and a challenge. Though small in scale, buds, leaves, blossom and fruit are every bit as characteristic as the shape and form of the whole to which they contribute. Indeed, often they will give the clearest clues as to the identity of a species.

For the artist who wants to develop pure drawing skills, there are few better ways than to spend time studying the structure and symmetry of such miniatures – for example, in the way that a leaf grows on its twig. Studies of this kind will give you a greater understanding of trees as a whole. You will discover the enormous variety of shapes, textures, growth patterns and colours that may be found in just one species of tree, and become aware of the striking differences that mark out one species from another – the large, showy blooms of the horse chestnut, for example, as opposed to the discreet wind-pollinated flowers of the silver birch.

Still life

You can draw close-ups in the field or, if you prefer, gather your chosen 'raw materials' and take them home to work on at your leisure. Either way, it is possible to inject as much atmosphere in a still life made up of leaves and flowers or fruit as it is into a portrait of a whole tree. I hope that the illustrations shown on this and the following spread will give you a sense of how strong feelings of place and time can be evoked without having the whole structure in view to provide you with a frame of emotional reference.

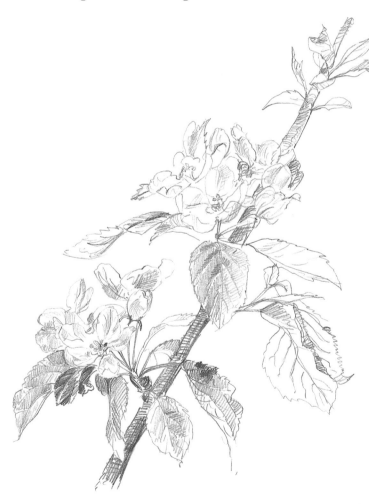

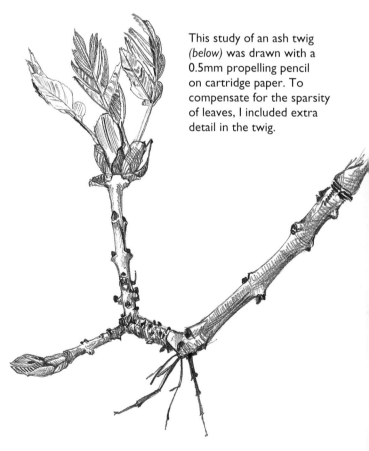

This study of an ash twig *(below)* was drawn with a 0.5mm propelling pencil on cartridge paper. To compensate for the sparsity of leaves, I included extra detail in the twig.

I made this study of apple blossom *(above)* quickly with a 0.5mm HB propelling pencil on cartridge paper. The leaves and blossom at the bottom of the twig have been highly developed in terms of detail and tone to provide the focal point.

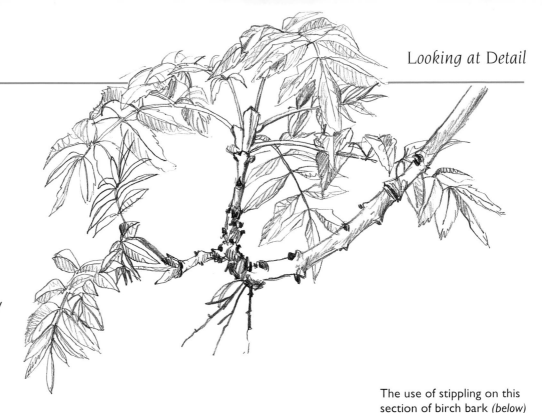

This drawing *(right)* shows the same ash twig shown on the opposite page, and was produced using the same materials. Drawn only a week later than the first study, it illustrates the rapid change that takes place as the leaves unfurl.

The use of stippling on this section of birch bark *(below)* produces an almost abstract effect, in contrast to its use in the drawing of the birch leaves and catkin *(left)*.

In this illustration of birch leaves and catkin *(right)*, I used fine stippling to create detail. Compare this treatment with that used in the drawing of the bark of the same species *(far right)*.

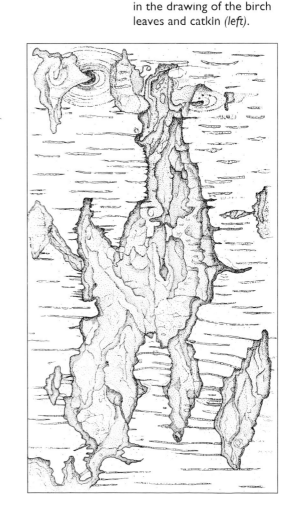

Composing a still life

In order to create a successful still life, you must aim to achieve a balance between the elements in your composition. The apple blossom illustrated opposite has a strong diagonal which gives structure and dynamism to the composition. I drew the leaves on the right-hand side of the twig in simple outline because if they had been tonally rendered, as have the leaves on the left-hand side, they would dominate the composition.

Conifers are particularly suitable as subjects for still life; their cones come in many shapes and sizes and the variety of patterns offered by their needles (see example on page 20) will challenge and develop your drawing skills.

Still life design

The different shapes and textures of the various tree parts lend themselves for use as decorative still lifes. You can create a design by using parts from the same species or by combining elements from several. Depicted below are a mixture of hawthorn twigs and oak leaves with acorns, a combination offering strong visual interest.

Before you start your composition, you must decide how you are going to fill the paper with your chosen forms to create a unified design. In a drawing of this sort, it is important to strike a balance between positive and 'negative' (the shapes created by the spaces between objects). This has been achieved in the example shown by leaving spaces within the design and providing areas of detail throughout the whole composition.

One of the beauties of this type of design is that, once a balance has been achieved and is maintained, it offers limitless opportunities to extend the drawing on either side.

Series work

As you become more experienced at rapid sketching, you can try your hand at producing a series of still-life drawings. By making drawings regularly throughout the year, you can capture the life cycle of a tree, from buds and blossom in spring, buds bursting into leaves, to full leaf, and finally leaf fall.

The series of detailed studies shown opposite depict the leaf, flower and fruit of the horse chestnut at different times in the tree's annual cycle. They required detailed observation in the studio and were made from twigs removed from the tree for this purpose. In my first drawing, an opening bud is shown together with a bud which has opened to reveal the young leaves unfurling. The middle drawing shows the mature, palmate leaf with the inflorescence made up of several separate flowers.

A design made up of hedgerow plants. I used black ballpoint on ivory board enabling me to give the outline emphasis and execute fine hatching.

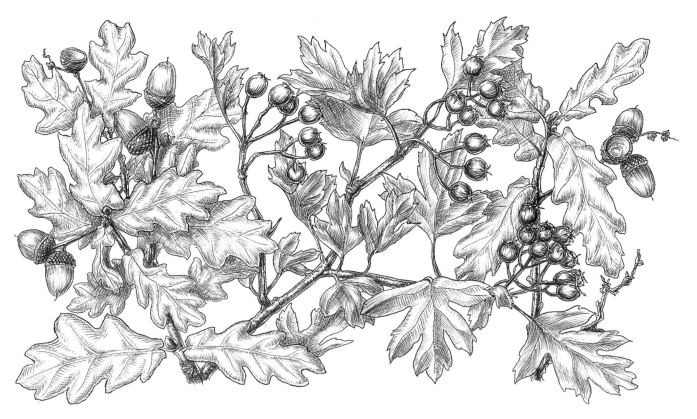

I used a variety of hard pencils of grades up to HB to produce the fine gradations of tone to explain the form of these delicate flowers and distinguish them from the leaf behind.

The last illustration shows the wilting leaf and ripe fruit in autumn. Careful rendering with hard pencil on smooth paper enabled me faithfully to reproduce the robust form of the conkers, in contrast to that of the dying leaves, which I treated in a much more delicate fashion, to suggest their gradual decay.

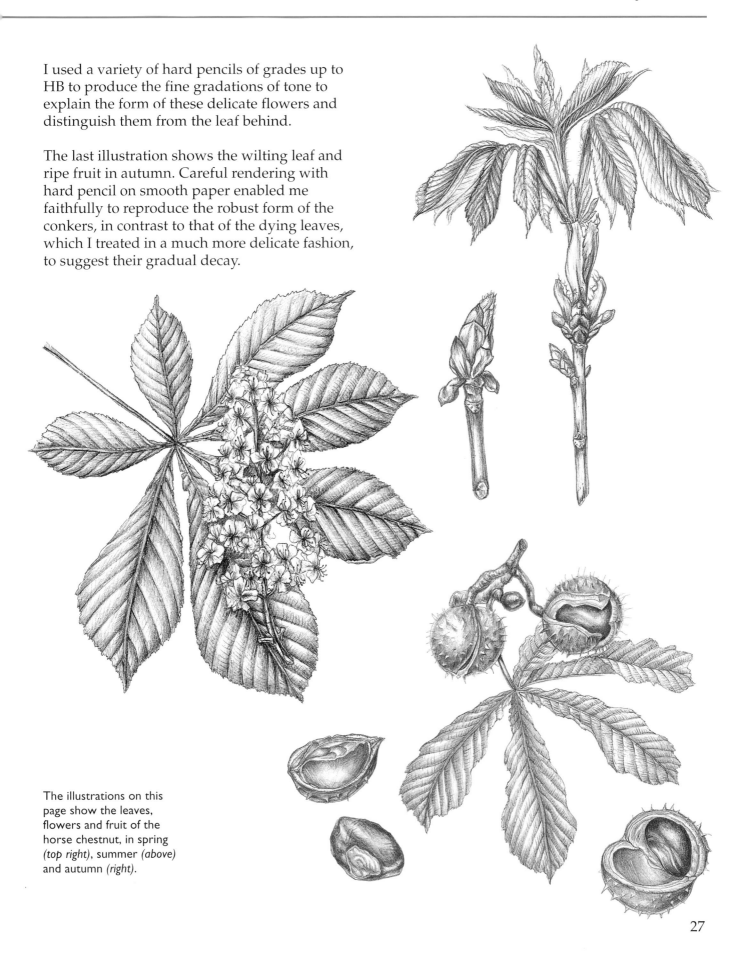

The illustrations on this page show the leaves, flowers and fruit of the horse chestnut, in spring *(top right)*, summer *(above)* and autumn *(right)*.

Proportion and Measuring

To draw a specific tree and make it recognizable as a particular species, you have to pay attention to proportions. Individual trees of one species will vary in appearance but will be sufficiently alike to be recognized as belonging to that species. Within each species there are rules which govern the way branches divide from the trunk and where and how they fork. Applying this knowledge is particularly important when drawing leafless deciduous trees in winter.

Placing your drawing
Always think about size and placement on the paper before you begin your drawing – remember, trees are large. Beginners often start at one point on the paper, work outwards and then discover that there is not enough room for the rest of their drawing. There is an established procedure which it is advisable for the inexperienced artist to follow.

In order to get the proportions of your drawing right, first analyze how the tree is constructed. Looked at in simple terms, it appears as a network of cylindrical shapes. Make a light sketch of this skeleton before you go on to finalize the drawing, gradually working over the whole area to balance the tone and detail.

Measuring
Before you commit your drawing to paper, however, you will need to measure the proportions of each of your basic shapes. I usually begin by establishing the horizon. This is done by ascertaining the point at which the sky and ground meet, somewhere along the length of the trunk of the tree. Holding my pencil vertically at arm's length, I slide my thumb up and down until I arrive at a measurement of the distance between the horizon and the base of the trunk. I then transfer this proportion to the drawing paper.

Having established the size of the trunk, I use the same technique to measure the principal branches, and make small marks on the drawing to note where the boughs cross or fork. In addition to measuring the length of each branch, I note where each intersects with another and mark the paper accordingly, building up a grid of horizontal and vertical measurements. This process helps me to construct the branches so that they are both in proportion and at the correct angles relative to the trunk.

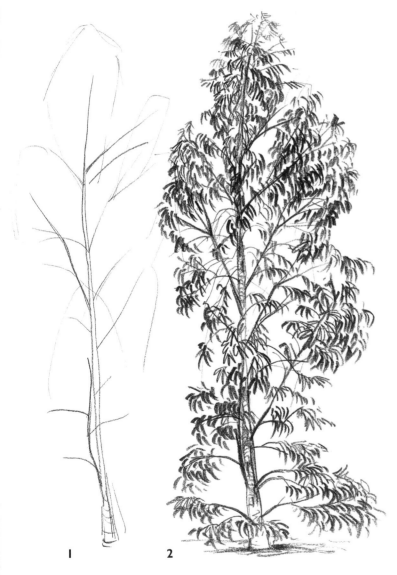

1

2

1 I began drawing this young eucalyptus tree in skeleton form.

2 Using charcoal pencil, I made marks to suggest the long, slender leaves, adding them to a trunk developed from the basic sketch.

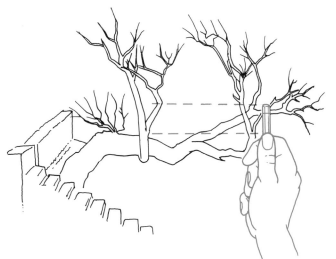

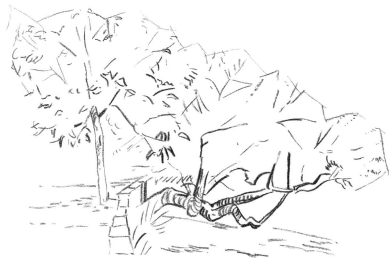

1 Using a pencil to measure the proportions of the two trees, I made a few marks, to define the trunk and branches before producing an outline.

2 I then developed the drawing by establishing the size and shape of the trunk and main branches of the tree.

3 In the finished charcoal drawing, I used short, gestural dashes for the willow and bolder sweeping marks for the Indian bean tree.

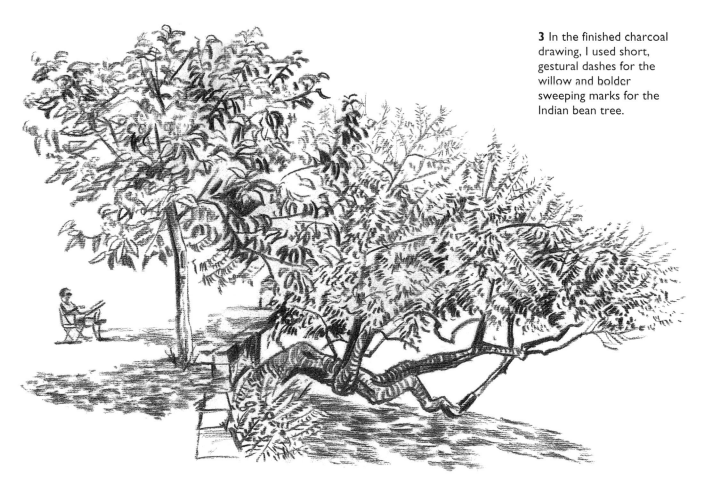

Negative spaces

A technique that may be useful both as a drawing aid and as a check on the accuracy of your drawing is to look at the 'shapes' or spaces, between the branches and their relationship to each other and the whole. Looking for these negative spaces will help you to realize how branches twist and turn and how they gradually taper into one another. If you get these spaces right, you will also succeed in getting the proportion of the branches correct.

Three-stages to drawing a tree

In the first sketch on the opposite page, as well as measuring the size of the trunk and branches, I gauged the height of the major forks and where one branch passed behind another above the horizon. I used verticals to align upright branches and check their positions relative to one another. In the second sketch, I checked angles by extending lines to see how and where they intersected with other parts of the tree. The final stage includes added background and detail.

These drawings show the development in a study of a silver birch in winter, using the principle of 'negative space'. The dark form of the conifer in the background has been used as a foil against which the spaces between the white birch branches can be gauged.

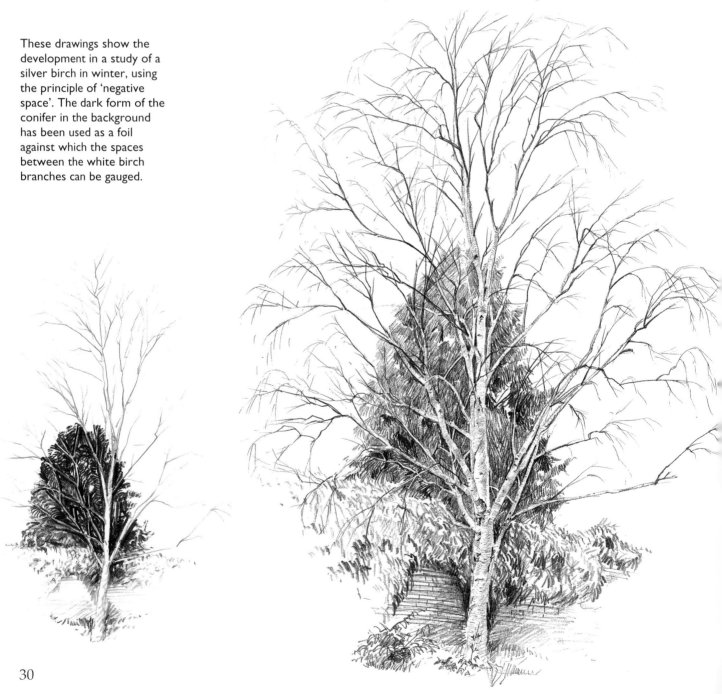

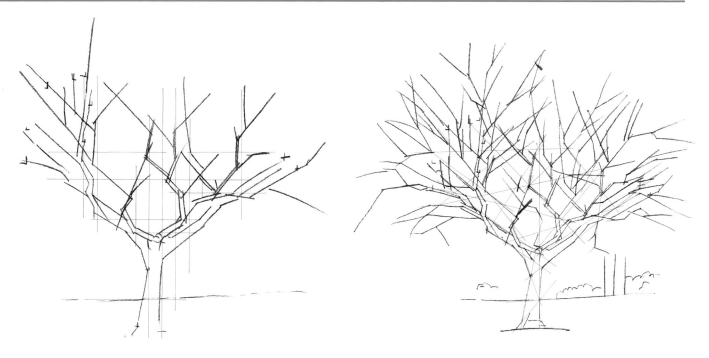

1 In this drawing the horizon and trunk have been established, the branches and where they intersect with one another have been marked, and verticals used to check relative positions.

2 Once the basic skeleton has been drawn, fewer measurements are required. Angles can then be checked by extending lines to see how and where they intersect with other parts of the tree.

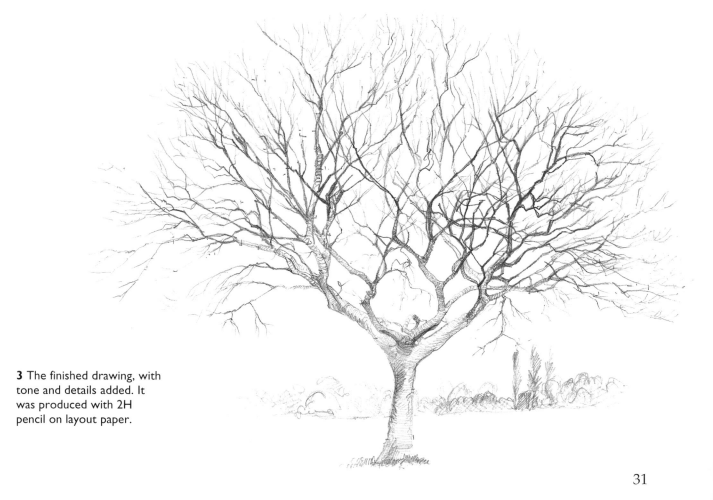

3 The finished drawing, with tone and details added. It was produced with 2H pencil on layout paper.

Structure and Form

Drawing trees successfully requires an appreciation of their three-dimensional form. Failure to do this will result in a drawing that is flat and unrealistic, especially when you are tackling the most difficult part to depict well, the point where branches divide from the trunk. These may appear to merge with the trunk itself, to be stuck on it or to disappear behind the tree.

When you look at a tree that you are about to draw, imagine the almost circular shape that a cross-section of one of its branches would reveal, and try to convey the roundness of this form in your drawing.

Two studies of the same log. The first *(below left)*, done in dip pen and ink, uses bracelet shading.

The second *(below right)*, drawn in charcoal pencil on cartridge, uses marks in varying tones.

Using shading

Once the outline of the drawing is complete, three-dimensional form may be conveyed by shading. The width and weight of the shading marks can be varied depending on the shape and character of the subject.

In the illustration below left, I used 'bracelet shading' – curved lines following the form – to suggest the roundness of the log. I used rings to achieve the shape of the curved end, and simplified the background area to give emphasis to the branch coming forward in the top left-hand corner. The illustration below right shows a conventional method of shading. Here, gestural marks made in varying weights are less successful in suggesting the three-dimensional form than is the more precise bracelet technique.

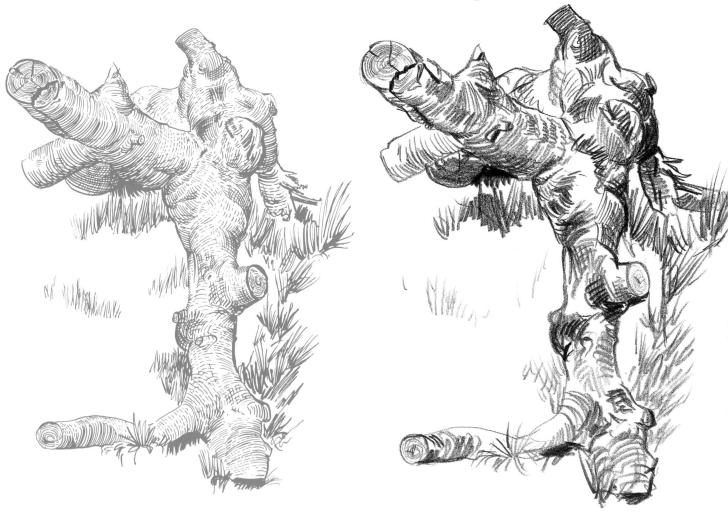

A cedar tree, depicted in willow charcoal on cartridge paper. I used the edge of the charcoal stick for the large areas of tone on the trunk and to indicate the twiggy branches of the tree behind.

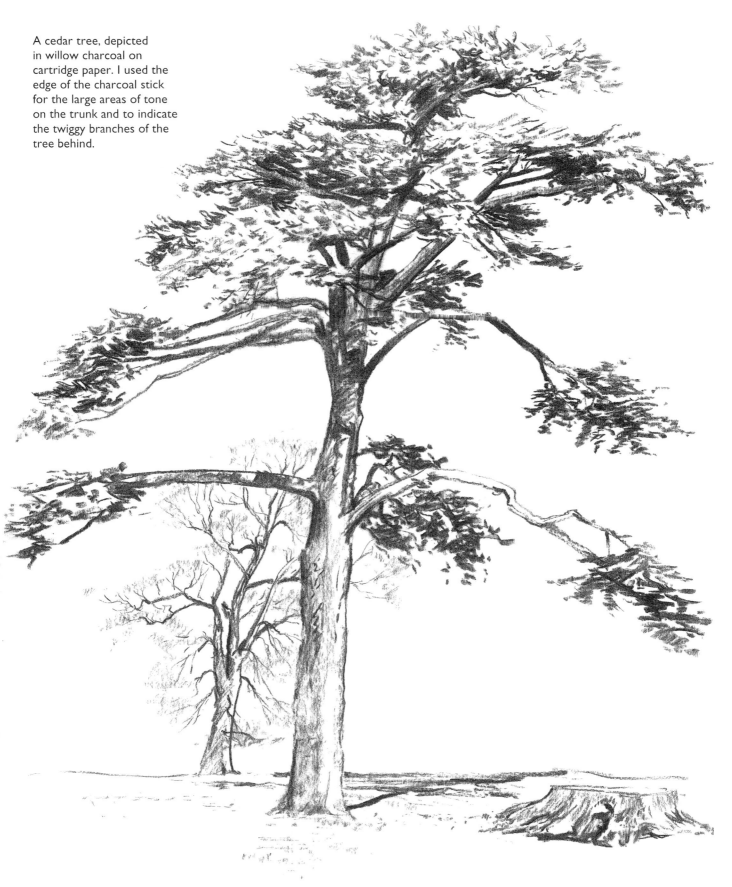

Trunk and roots

The principles used to depict branches can also be applied to drawing the whole tree. When seen in cross-section a trunk will not necessarily be perfectly round and may reveal a series of vertical ridges or buttresses. Roots are usually only seen as part of a curve breaking the surface of the ground, but where they are more in evidence can be treated like branches.

Great care was taken to ensure the accuracy of the outline stage of the illustration of the beech tree (below left). Observe the still-visible measuring marks and extrapolated lines. Special attention was given to the way the curved surfaces blended into one another. Realistic depiction was achieved by taking one outline behind another or by adding extra lines.

In the second illustration (below right), executed in ballpoint pen on layout paper, the leaves and foreground twigs were drawn over the outline, before the tone and background canopy of foliage were added. Tone on the trunk, branches and roots was achieved by extensive use of shading and hatching. The latter is particularly evident on the buttressed lower trunk. The effectiveness of its use can be judged by the degree to which it suggests three-dimensional form.

1 An outline drawing of a beech tree, showing measuring marks and extrapolated lines.

2 The finished drawing, in ballpoint on layout paper, showing extensive use of shading and hatching.

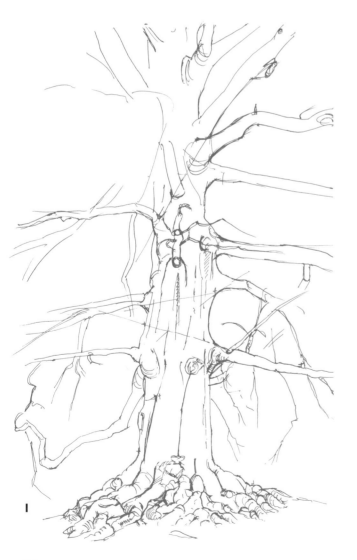

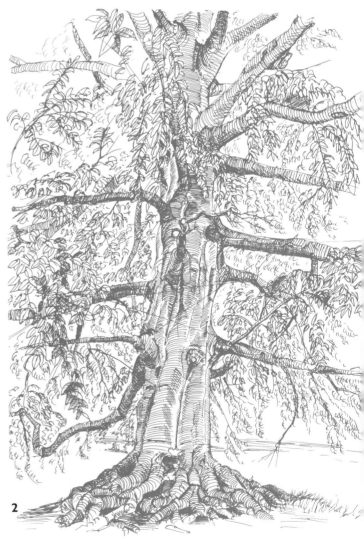

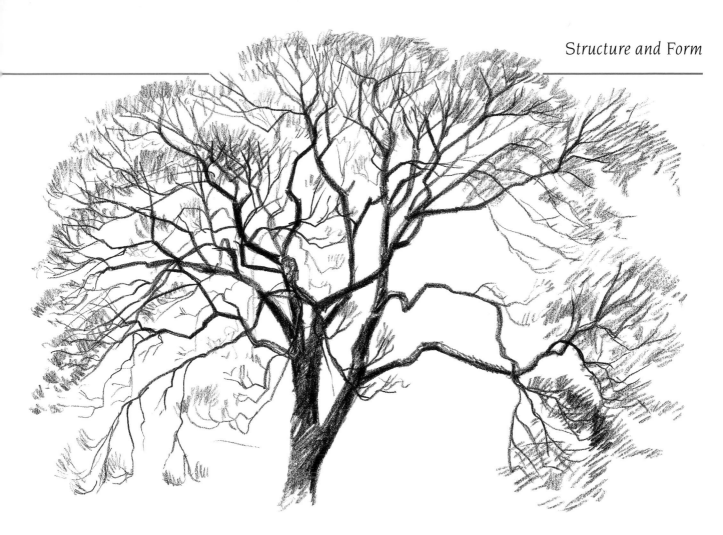

Twigs in winter

It is very difficult to make a winter tree look realistic. The masses of twigs, if badly executed, can make the tree appear top-heavy – so the secret is not to try to draw every single one. If every twig were reproduced, the drawing would consist of solid hatching and no sky would be visible. Each mass of twigs need only be generalized. To achieve this, reduce pressure on your pencil and draw the twigs in the direction in which they grow. Shorter marks may be added for additional twigs.

In my two examples of a tree top in winter, I used different media. In the upper drawing, I rendered the mass of branches and twigs in conté crayon, using a hatched tone. For the lower drawing, I used a dry, 4B water-soluble pencil to produce the marks indicating the twig masses. (I prefer using this type of pencil for this purpose because of the blackness and thickness of the lead and the fact that it does not break as easily as an ordinary pencil.)

In these quick studies, in conté crayon *(above)* and water-soluble pencil *(below)*, I concentrated on conveying the three-dimensional form created by the network of branches and twigs.

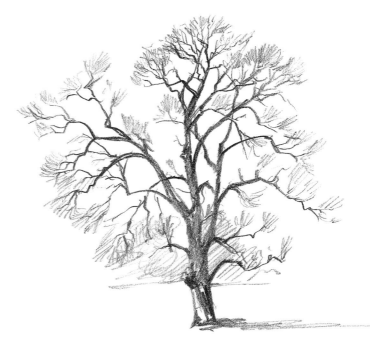

Light and Shade

So far I have explained structure and form primarily in terms of line drawing. However, in nature no outlines exist; they are an artificial concept of our devising and in reality we perceive the world around us in graduated tones of light and dark.

Tonal values

The tones in an average view are far too complex to copy faithfully on to paper. It would be almost impossible for us to reproduce the subtle graduations of light to dark found in a black and white photograph. There is a method you can employ to simplify and reduce tonal values. If you squint at a scene, or remove your spectacles if you need them for long-distance vision, the detail will become less distinct and small, localized variations in tone will no longer be visible. You will then find it easier to draw the large areas of tone against each other.

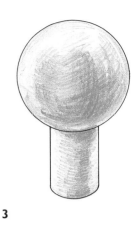

I

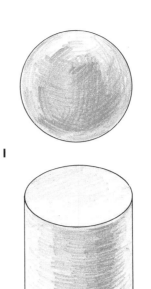

3

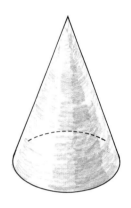

2

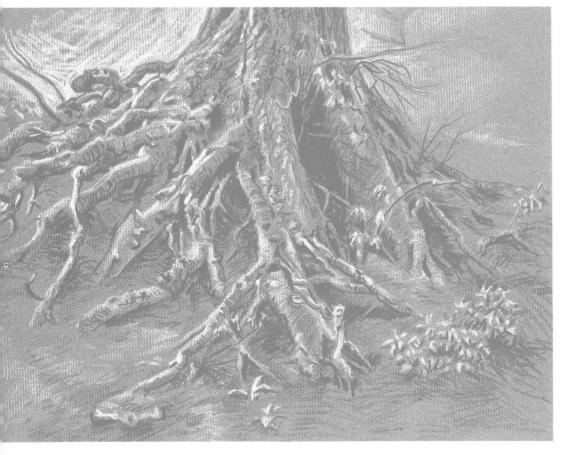

Simple forms lit by a single source of light *(above)*. When combined, the sphere and cylinder (**1** and **2**) can be thought of as a deciduous tree (**3**). The cone shape is typically found in conifers. Drawing shapes lit in this way will teach you to recognize the light and shade patterns evident in nature.

For this low-key study of a chestnut *(left)* I used white and black conté on mid-toned Ingres paper. The craggy shapes of the exposed roots provide an interesting subject. Black was used for the shadow and white for the highlights.

Light sources

Drawing a simple shape like a sphere when it is lit by a single source of light, such as the sun, gives insight into how a three-dimensional shape reveals its form from the shadows cast upon it. Cylindrical forms also have distinctive patterns of light and dark. Remembering these simple forms can help us to interpret the seemingly complex forms we see in nature.

High and low key

When you are familiar with tonal variations, you may wish to experiment. You can achieve different tonal effects by using dark as opposed to white paper. A drawing comprising mainly light tones, with possibly some dark accents, is said to be in 'high key'. Conversely, a picture using a language of dark tones, with light areas confined to the highlights, is said to be 'low key'.

In this study of a large Turkey oak I used HB and 2B pencils. I made dark vertical marks to suggest the texture of the bark and to create a three-dimensional effect. Leaving areas of white paper blank has provided the highlights.

Artist's Tip

Squinting at a scene will help to simplify it, thus enabling you to concentrate on rendering the large areas of tone.

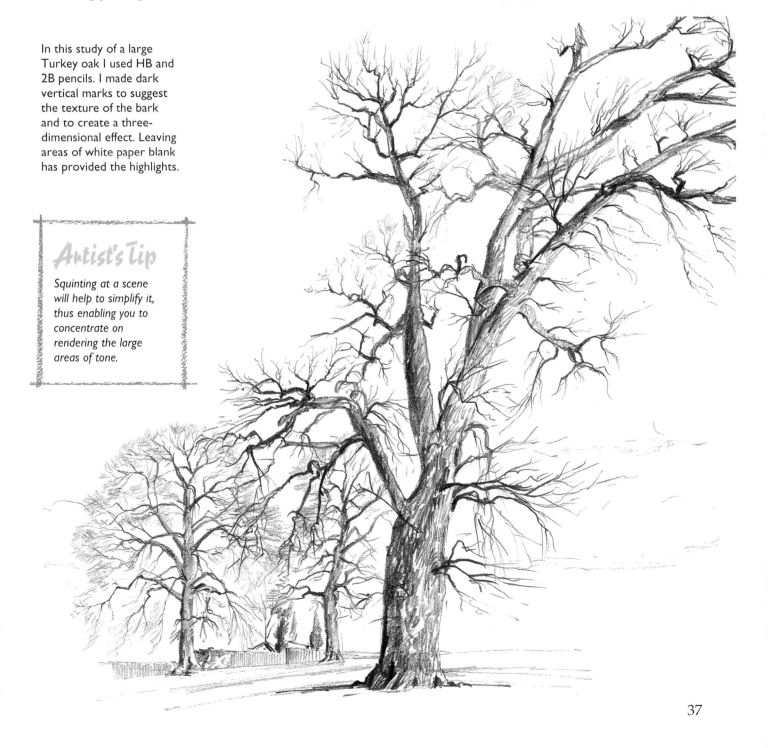

Seasonal changes

Trees in summer present a different set of problems for the artist from those in winter. The cylindrical forms of trunks and branches, which are to the fore in a winter profile, are masked by a mass of leaves. The shape produced by this mass is not necessarily solid, however, and may have gaps in it through which the sky can be seen. You will need to use tone in order to suggest the form of the tree without losing the pattern created by the leaf masses.

It is a mistake to try to draw the leaves in detail; to do so will, on all but the smallest of trees, have a flattening effect and give no suggestion of the tree's three-dimensional shape.

Simply shading the shape will not produce the required effect either, and is only effective when depicting trees which are in the distance. The correct way to tackle the problem is to establish the shape on the paper using the minimum of outline. In effect, you have to use tone to draw the form.

You will see from my example below that I used a variety of techniques to represent tonally the three different types of tree in the group. Contrast was produced by suggesting different patterns of light and shade. I achieved this by varying the density of the masses of foliage and by using different pencil marks to denote the individual types of tree.

A scene with three different tree species, rendered in coloured pencil on cartridge paper. Note the variation in the type of mark used to distinguish the species. The grassy area in the foreground was produced with a minimum of strokes.

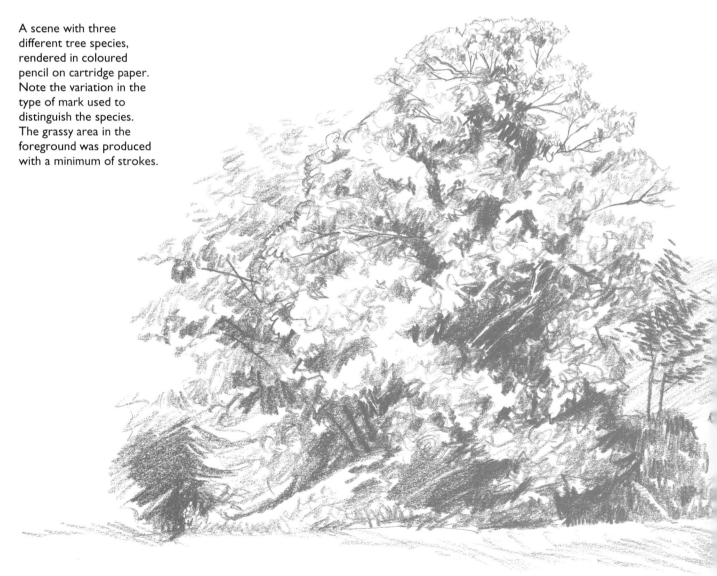

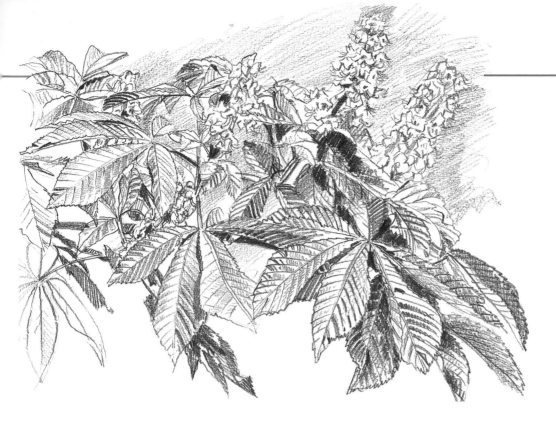

A close-up, tonal study of horse chestnut leaves, using a 6B pencil on watercolour paper. Such studies provide good practice before attempting to employ tonal variations in a drawing of a whole tree. (They can also work well in their own right, with just as much tonal drama as a larger subject.)

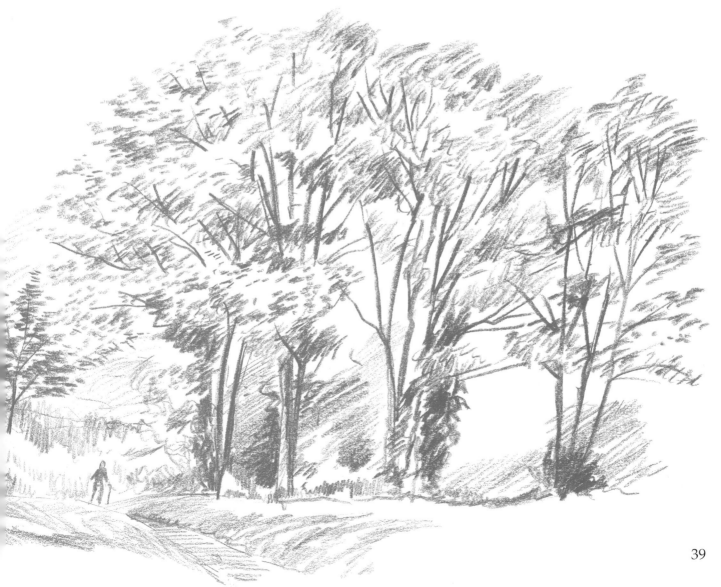

Texture

In order to give an indication of surface texture in your drawings, you need to build on the techniques of recording light and shade. These will enable you to suggest not just the form of the tree but the surface relief of the trunk and the smoothness or otherwise of its leaves. You do not need to draw every crack and crevice in the bark or delineate every leaf, but the marks that you make must indicate differences in texture.

These marks can also be used to convey movement in wind-blown leaves, cast shadows, differentiate between foreground and background, and create dramatic atmosphere.

As you will see in the following series of drawings, creating a convincing texture involves using marks effectively to convey a suggestion of this quality, and capturing the variations in light and shade caused by the surface relief.

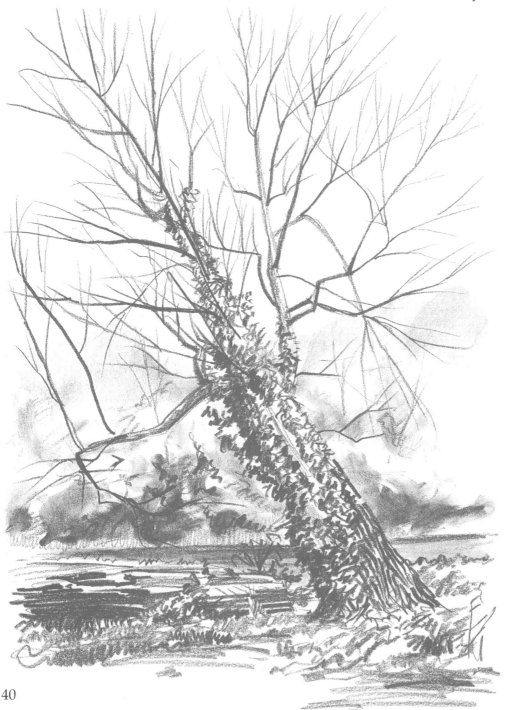

This willow was rendered in water-soluble pencil on cartridge paper. For the surface of the water and the land beyond, I smudged the pencil marks with a wet finger, thereby creating a misty effect. I used bold marks to suggest the ivy and the remains of the fallen trunk on the left. The ridged bark was worked in greater detail, using dense marks.

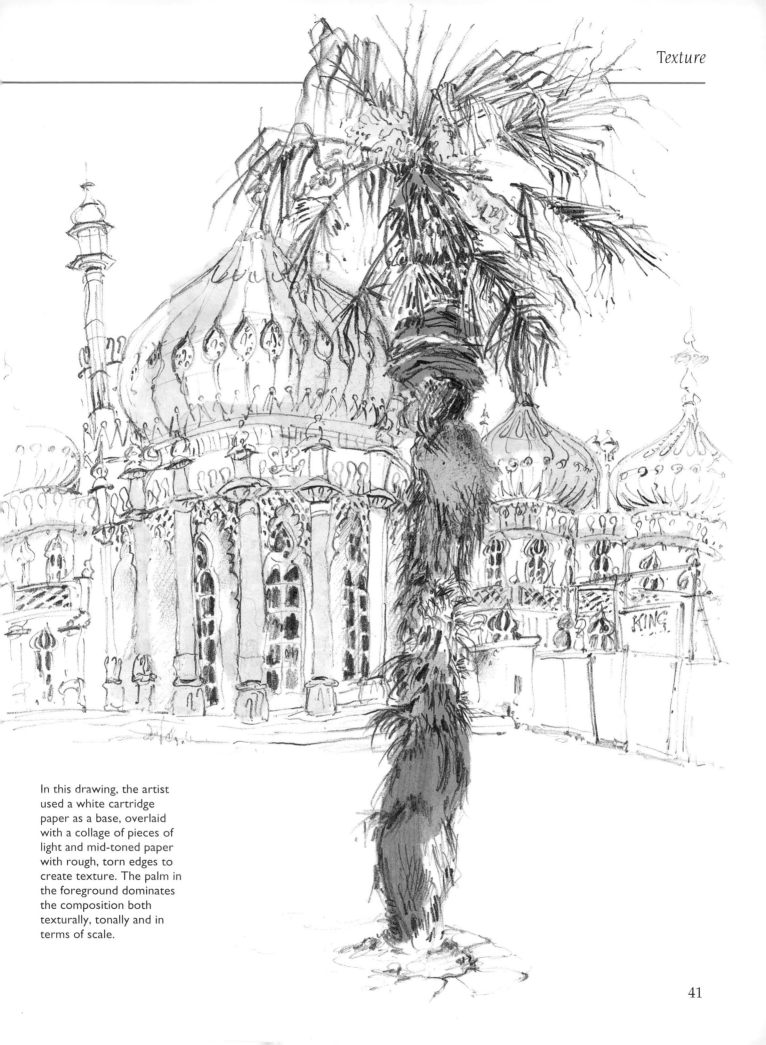

In this drawing, the artist used a white cartridge paper as a base, overlaid with a collage of pieces of light and mid-toned paper with rough, torn edges to create texture. The palm in the foreground dominates the composition both texturally, tonally and in terms of scale.

Choosing a focal point

Before you begin drawing, it is important to decide which areas of the composition you feel are most interesting and wish to emphasize texturally. Having selected the main focal point, look at the whole subject to check whether any other area detracts from it. If any parts have an over-dominant surface pattern which may attract the attention away from your chosen focal point, change, simplify or omit as necessary.

It is a mistake to try to render in detail surface relief across a whole drawing. This approach has several disadvantages for the artist. It takes a great deal of time during which the light and weather conditions may change. The result rarely justifies the effort and a drawing with an even degree of detail overall can end up looking flat and lacking an obvious centre of interest.

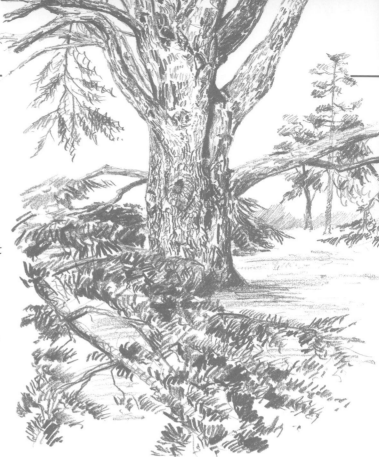

The rugged surface of a cedar trunk, rendered in 4B pencil *(above)*. Note the contrast between the loose marks used to suggest the foreground foliage, and the closer, more intense marks on the trunk.

The quickest way to convey an impression of surface relief is to create a pattern of varying marks. There are dangers inherent in this approach, however. The problem of lack of obvious focus may arise again if your marks are too generalized across the whole drawing.

Striking a balance

If your finished drawing is disappointing, it may be that you allowed the medium to control your actions. When this happens, your concentration is distracted from looking properly at the subject. The solution is to try to strike a balance between the detailed and the mark-making approaches. Look at the drawings in this book and see how an effective compromise has been achieved between detail and mark-making.

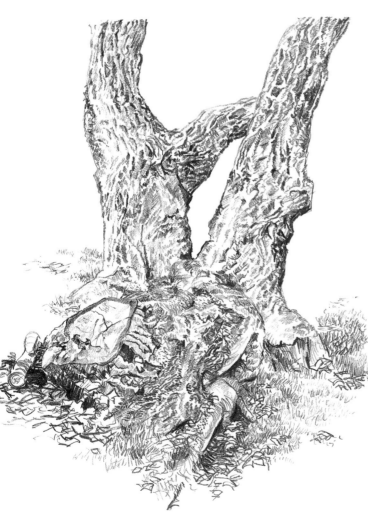

I used HB and 2B pencils on cartridge paper to make a study of this tree stump *(left)*. The interest here is in the contrast between the areas of cut wood, bark, exposed roots, moss, grass and the layer of dead leaves.

Media and texture

The drawings in this section of the book provide examples of how different media may be used to produce a variety of textures. With careful choice of media, different textures may be produced successfully in the same drawing; the drawing below provides a good example. Your selection of medium and paper will dictate the vocabulary of marks available to you and therefore the methods you can employ to make your picture. It is always a good idea to experiment with different media and become familiar with the repertoire of marks that each tool produces. You can utilize the knowledge gained from this process to create interesting new textures in your drawings.

This bold drawing was produced using a combination of Indian ink and white gouache. The artist's aim was to contrast the texture of the knarled tree trunk with the weathered wooden fence post.

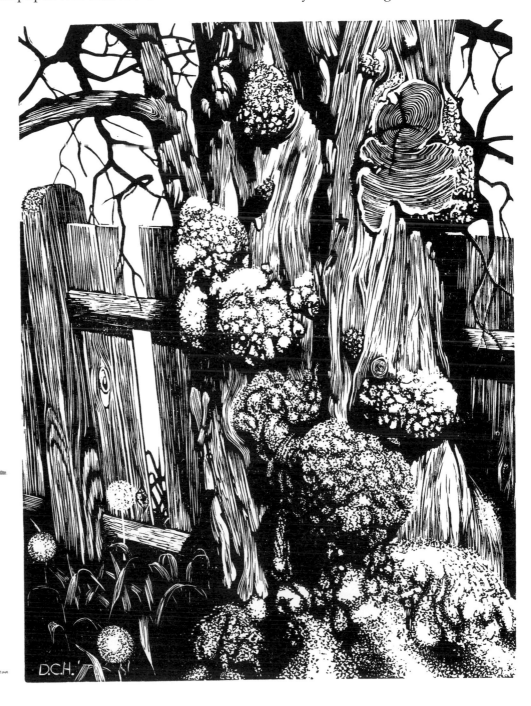

Artist's Tip

Always remember that it is up to you to decide what the focal point in your drawing should be. Be prepared to adjust other areas in your composition to accommodate the choice you have made.

Perspective

Perspective is the principle whereby objects, or part of an object, appear to decrease in size and density of tone the further away they are from you.

Perspective can be used to make sense of apparent changes in size of the various elements of a tree, although in practice it is often simpler to measure accurately with a pencil and use your knowledge of perspective to help you understand and draw what you are seeing.

When a single tree is the main subject of your sketch, the overall picture may benefit from minimizing the detail of the background. A strong atmosphere in this area may still be maintained by using a dark tone which will also serve to highlight the main subject.

Aerial perspective

You will notice that even on the clearest of days distant objects appear more hazy, less detailed and lighter in tone when compared with objects in the foreground. This effect is known as 'aerial perspective', a term used to describe the changes in colour and tonal values that may be seen as objects recede into the distance. If you study aerial perspective and learn how it works, you will be able to put it to good use in any scenes in which there are both foreground and background objects, giving your drawings a illusion of three-dimensional depth.

The nebulous washes of gouache in this drawing imply the presence of trees on the far bank of the lake and serve to suggest distance and give depth to the foreground of the picture.

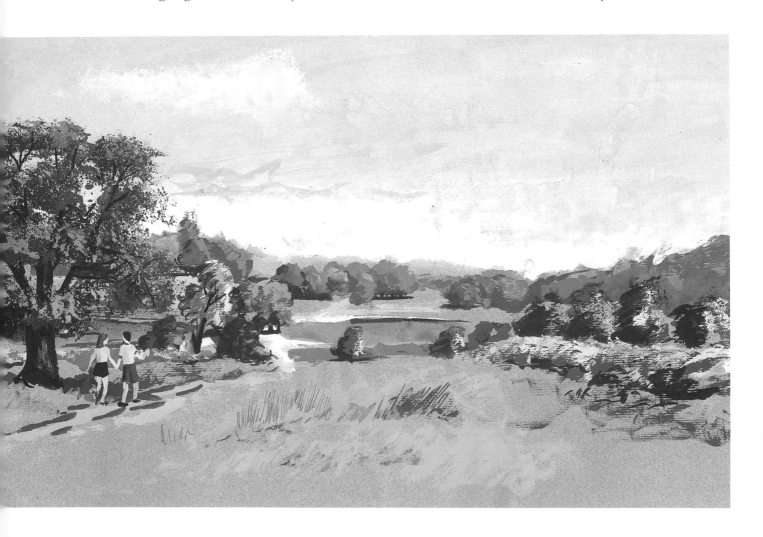

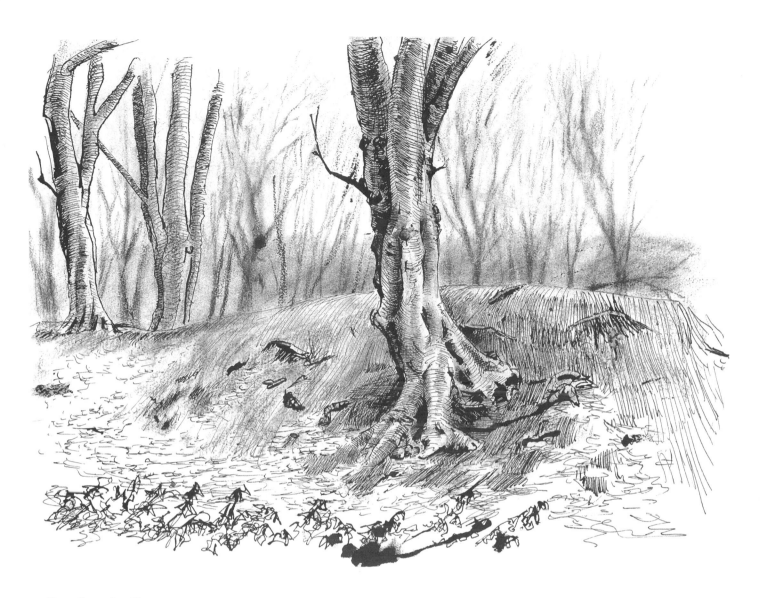

Creating depth

There are two ways to use aerial perspective to create depth: by simplifying the most distant objects, such as a range of hills, and by rendering them in a single light tone. Distant stands of trees, however, may require the addition of vertical shading to indicate their trunks. In forests, the effects of aerial perspective can be exaggerated to create atmosphere and also to simplify the background. Generally, in any scene, the detail and the widest range of contrasting tones will be concentrated in the foreground. But it is always wise to check the particular view you are drawing to confirm this.

For this mixed media drawing of a beech wood in mid-December, I used dip-pen and Indian ink, and charcoal on watercolour paper. The pen and ink were used mainly to produce the detailed work on the central image in the foreground, the weeds and dead leaves. The charcoal provided the tone and the blurred outlines of the trees in the background.

The mood of the drawing is enhanced by the use of ink blots and runs, and smudging of the charcoal. The slope of the bank leads the eye to the trees in the midground, in the left of the picture. The bank also provides a break between the detail evident in the working of the foreground and the simplified tree trunks in the distance.

Linear perspective

There are two aspects to linear perspective. The first is that objects in the distance appear smaller than objects closer to the spectator. For example, a row of trees that you know to be identical in size and shape will appear to diminish in size as they recede into the distance.

The second is that parallel lines appear to meet in the far distance. A long, straight path, for example, will narrow to a point on the horizon. Trees are far less regular and ordered than buildings or streets, but the rules of linear perspective still apply. The diminution of scale is most apparent in scenes such as the avenue opposite, where lines drawn through the tops and bases of the tree trunks will coincide at a point on the horizon, the vanishing point. All horizontal lines running in the direction of the avenue will behave in the same way. Any object or person in the picture will also become smaller correspondingly. Whatever the perspective angles, tree trunks will always remain vertical.

Working with perspective

If you imagine standing at a junction of two avenues of trees, each will recede to a separate vanishing point on the horizon. When the trees are equally spaced it is comparatively easy to represent this spacing on paper, with each gap getting slightly smaller as the trees recede.

When you draw individual trees, branches pointing towards or away from you will be 'foreshortened', widening or narrowing along their length, according to the rules of perspective.

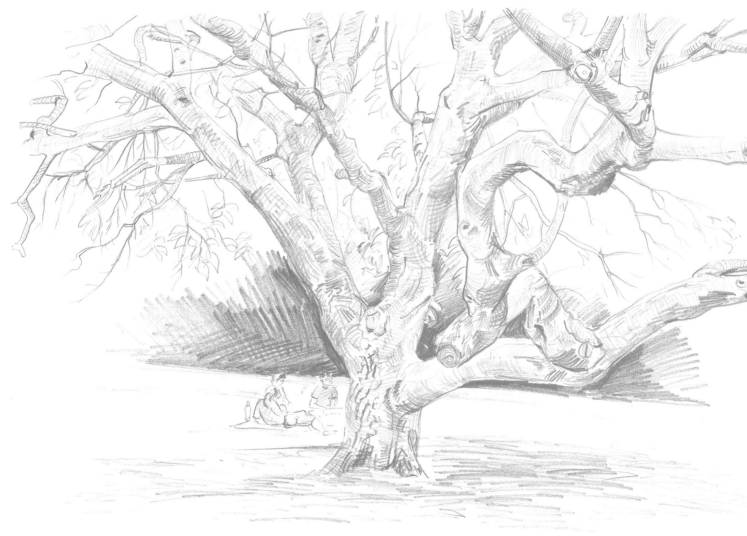

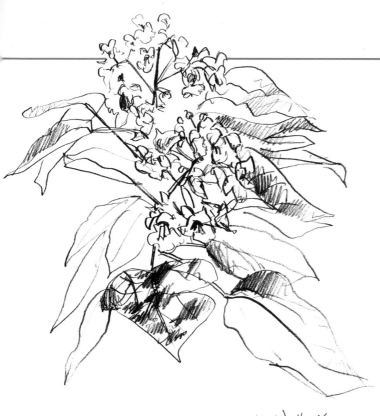

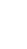

On paper these trees and the perspective lines associated with them will form a four-sided shape. Adding two diagonals will find the midway point between the two lines, enabling you to draw in a third, horizontal line. If the four-sided shape that you have drawn is half of a larger one, extend the diagonal which passes from the bottom corner to the middle in order to establish the position of the next tree.

Perspective is not an indispensable ingredient for an interesting picture. However, the rules of perspective are there to help you, and you should not allow yourself to feel intimidated by them. It is always better to distort perspective through personal choice than ignorance.

The rules of perspective apply whatever the size of your subject. In this detail from an Indian bean tree *(above)*, foreshortening – a form of perspective – has distorted the shape of the leaves pointing directly at the viewer.

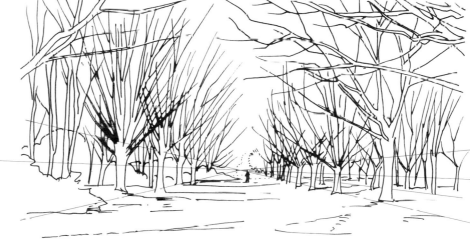

I used a fibre-tipped pen on tracing paper to draw these two views of an avenue of trees. The first illustration *(above right)* shows the use of perspective. Lines connecting the tops and bottoms of two parallel rows of uniform trees converge at a vanishing point on the horizon. The second drawing *(right)* shows the finished sketch with detail added.

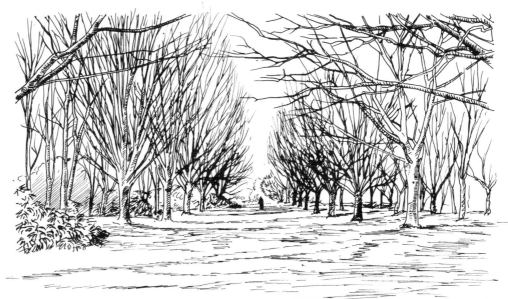

Trees in Groups

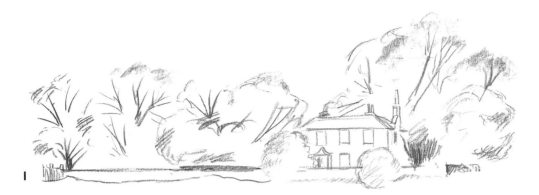

Three studies of a scene including several groups of overlapping trees, from a basic sketch (**1**), with detail added (**2**) to finished drawing with final detail applied (**3**). All drawings were rendered in conté on cartridge paper.

The thought of drawing trees in a group can be intimidating, but in actuality you will find many similarities between this exercise and drawing a single, large tree. Both require you to analyze and establish the structure and find a way of indicating a large canopy of leaves without rendering it as a solid mass. The main challenge lies in suggesting that each tree is distinct, and making marks that distinguish between, for example, a mass of small leaves and larger individual leaves.

You will also need to find ways of representing the tone of the different greens, either through your marks or the range of tones you employ. Providing clues that will help the viewer differentiate between the different species depicted will also be required.

Shape and proportion

Measuring to get the right shape and proportions is critical, because these are the major identifying characteristics of each species. They become even more important when species overlap in a group. You need to identify the most prominent tree and make it your focal point and the basis for your measurements.

Where the trees do not overlap, you must avoid making them look just like a series of studies on the same page. In order to do this, you will need to link the different elements of the composition to make a cohesive whole and to guide the viewer from one tree to the next. If there is no physical structure to provide a link, use shadows, clouds or the texture of grass or crops.

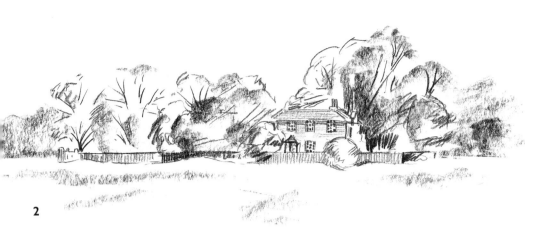

2

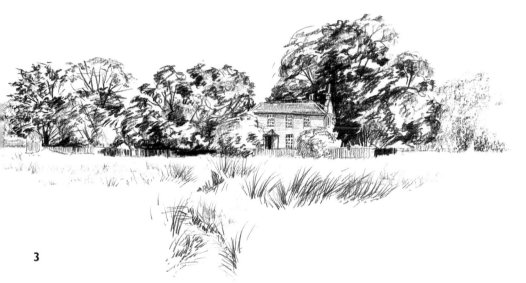

3

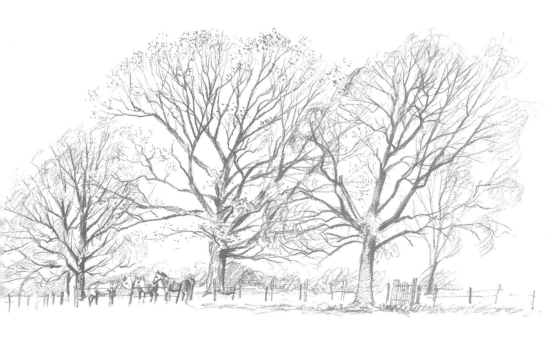

In this drawing *(left)*, I used the structure of the fence and the row of distant trees to link the series of individual trees. The horses provide scale.

Selecting and Composing

I am often asked why I choose to draw a particular tree. The choice, of course, involves not just the tree but the viewpoint, time of day and medium, and can be so wide that the beginner may be put off starting at all.

Drawing from your window
Drawing a tree or group of trees that can be seen from your home eliminates some of this uncertainty. It can also be a more effective exercise than choosing at random because you are already familiar with the subject. After all, you see it every day, or think you do. Drawing the familiar makes you question your assumptions and look at it with fresh eyes.

Working in the comfort and privacy of your own home has other benefits: you can return to the drawing as often as you wish, execute several drawings in a variety of media or chronicle changes in the weather or seasons.

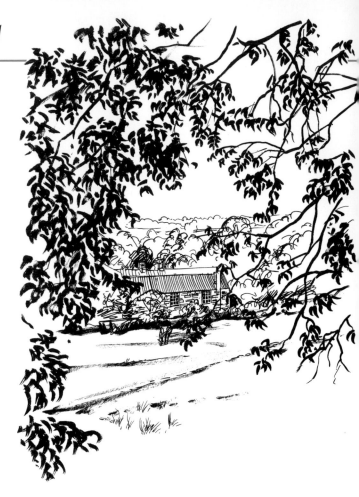

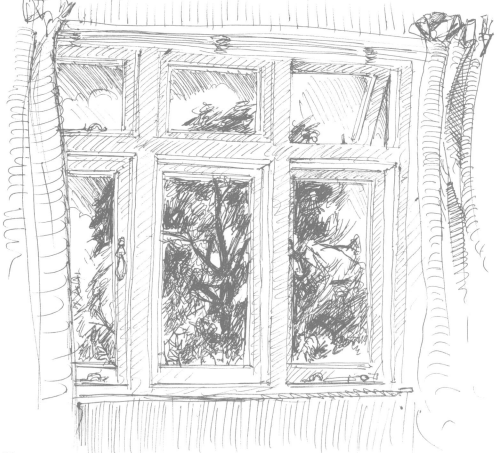

The branches of the overhanging tree in the foreground of this view create a natural frame *(above)*. A fibre-tipped brush pen and fibre-tipped fountain pen were used.

Two very different views of the ash trees visible from my home. In the summer view *(left)*, drawn in ballpoint pen, the window acts as a dominant framing structure. In the winter view *(opposite)*, executed in watercolour wash, a great deal of emphasis is given to the urban environment.

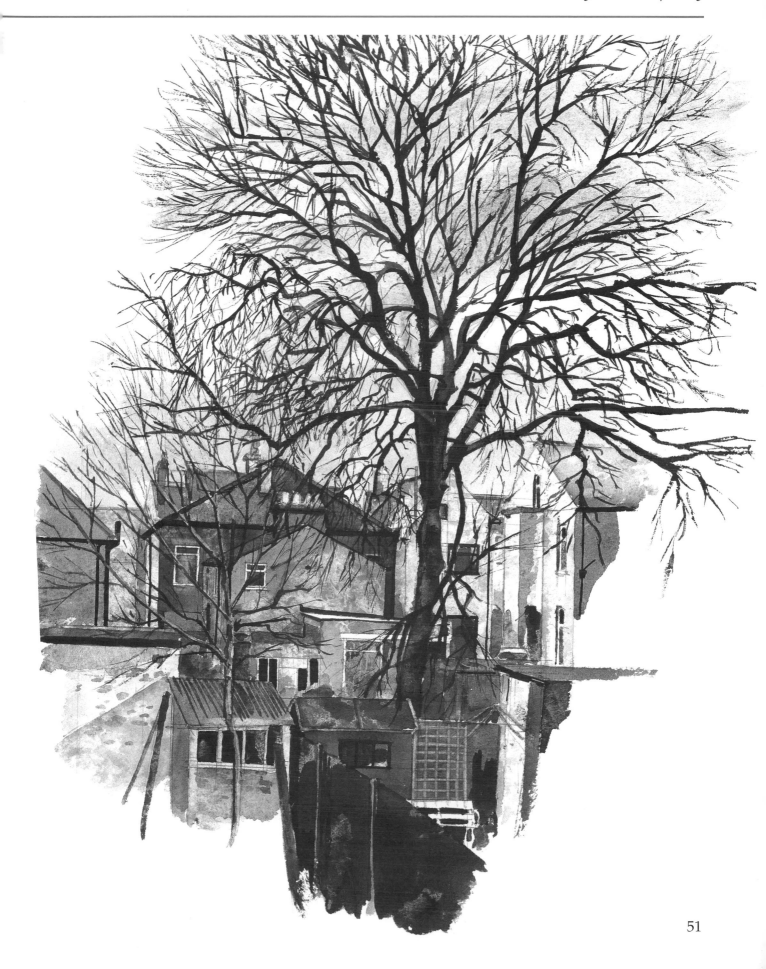

Drawing in the field
It is not necessary to go to exotic locations to find interesting trees to draw. The trees that we see every day, in the street or in the local park hold as many artistic challenges as rare specimens found in an arboretum. When selecting a tree to draw, always pick the one that *you* find interesting. It is never a good idea to sketch a subject because you feel you have to, or because others like it. A subject must have significance for you if you are to draw it in your own personal way.

Once you have selected your tree, walk around it until you reach a point where you feel the lighting is right and there is an attractive balance in the arrangement of the branches. If you cannot find a suitable position from which to create a 'good' composition which balances itself, do not become disheartened. Have confidence in your own critical judgement, and draw the scene as it is. The charm that attracted you to it in the first place will come out in your drawing.

Creating a frame with your hands *(above)* will help you to decide on the best composition by isolating the part of the view that you intend to draw.

Alternatively, you can carefully cut two right-angled, 'L' shaped pieces of card *(above)*, overlapping them, to create a frame for the view you wish to draw.

Avoid placing the subject in the middle of the paper *(above)*: this will divide the composition in half too strongly.

Instead, offset the subject as I have done in these thumb-nail sketches *(above* and *above right)*. This counteracts any visual imbalance in the composition by matching the shape and mass of the tree with other landscape features, such as the group of trees or the church.

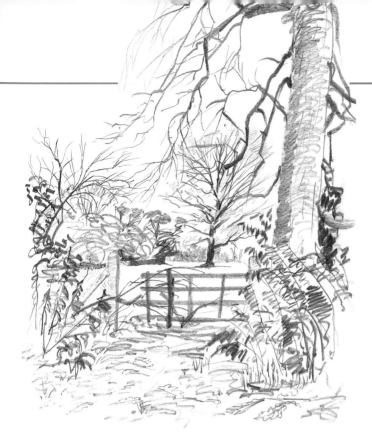

Framing a view

With experience, you may wish to look at ways of selecting part of a view to make a more pleasing picture. A frame, whether made from card or with your hands, may help you to decide what to include and how to place it on the paper. Making thumbnail sketches before you start the main drawing may also help you to create the picture of your choice. Remember that when you study a landscape you look at a variety of details, scanning across the view. You may include or omit such details at will.

The downward sweep of the branches of the main tree leads the eye to the tree in the distance *(left)*.

The curving path balances the composition *(below)*, despite the disparity in the size and number of trees.

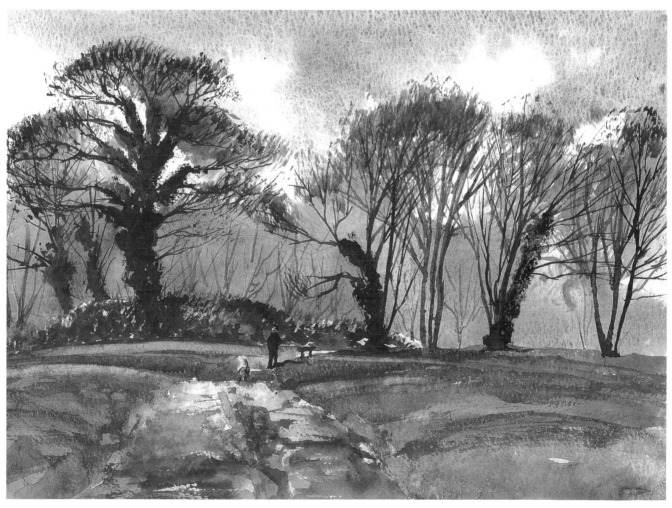

Sketching

The drawings that you make outside may not be as large or as elaborate as those you do at home, but as well as being successful sketches in their own right they may function as a record of a tree on several levels.

Memories of atmosphere or time of day are invaluable for future pictures, if only to enable you to add detail or backgrounds; even the least successful of your sketches may serve as reminders in years to come. Making notes about the weather or light conditions may enhance the meaning of a few gestural lines that define a sky or line of hills in a location sketch.

Do not think of the drawings of trees that you produce outside merely as portraits. Think of them as pictures containing trees which may lend scale or provide a centre of interest to a complete landscape. The ever-changing conditions in which you experience trees will provide atmosphere to make each of your drawings unique to a time and place.

In this picture, produced with compressed charcoal on cartridge, I had to draw quickly to capture the dappled light effect on the path, constrasting with the different pattern of light on the long grass.

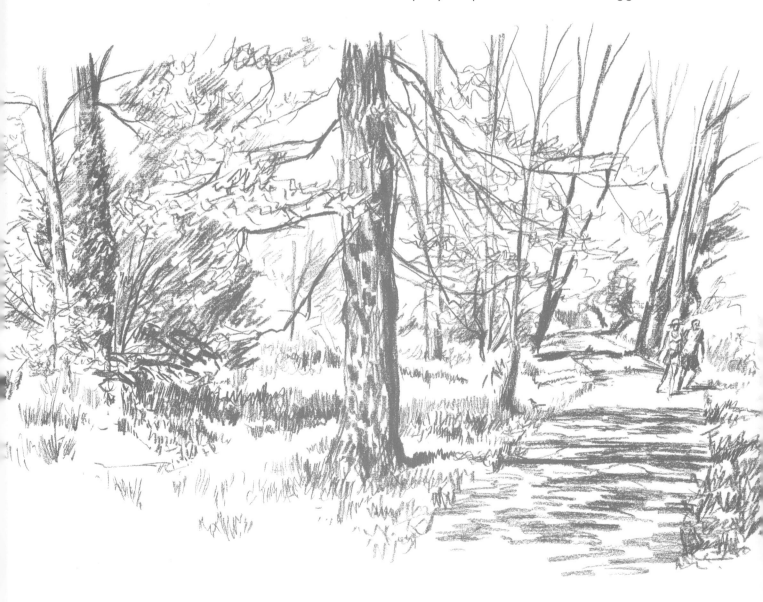

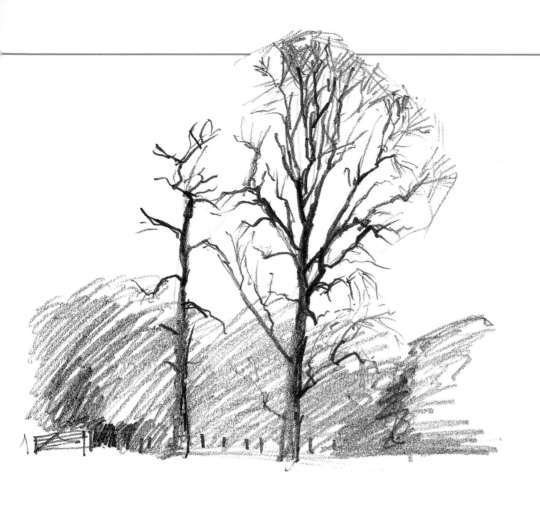

A typical rapid sketch such as this *(left)* can be produced in odd moments and used in one of two ways: amplified into a more elaborate work in the studio or used as the basis for background elements in another picture.

This sketch of distant trees on the boundary of a field *(below)* was executed in pencil on cartridge paper. The tractor tracks in the standing crop give an impression of scale.

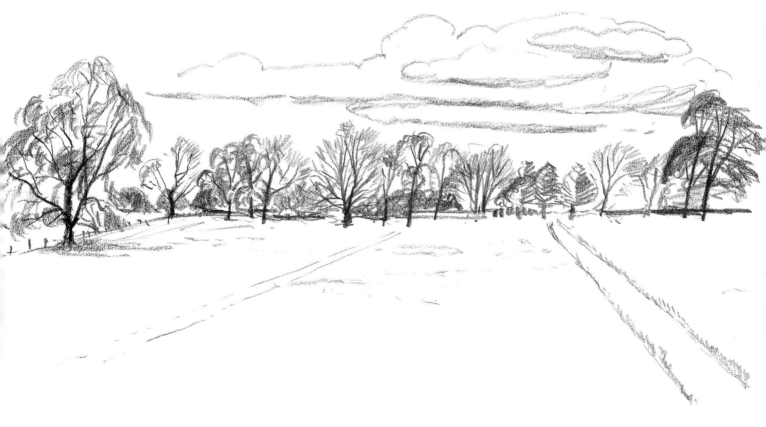

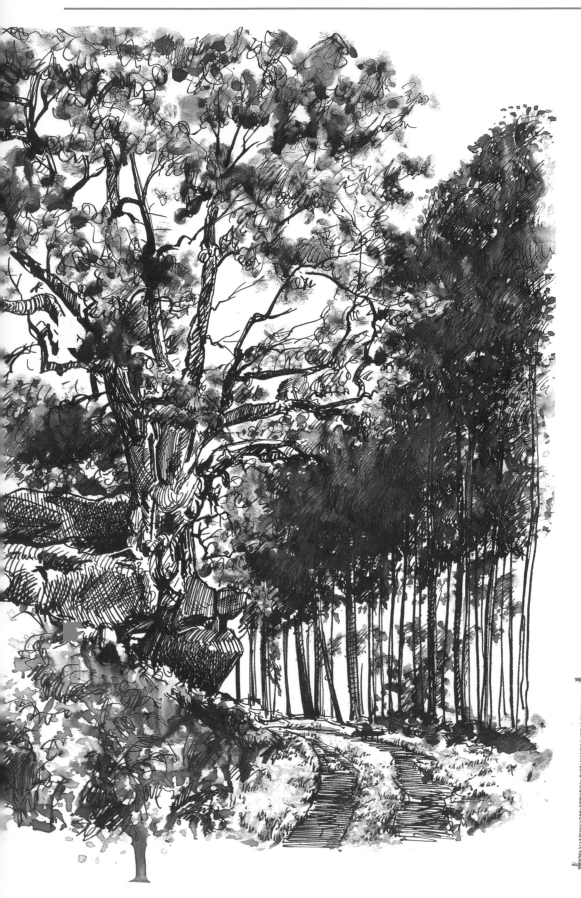

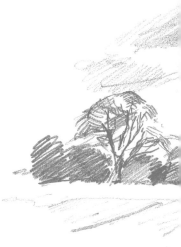

This rapidly executed sketch of trees surrounding a field *(above)*, does not provide detail, but serves as a visual reminder of the scene, and of the tree masses and tones.

I used a fountain pen with water-soluble ink for this scene, drawn in wet conditions *(left)*. The dark leaf masses of the pines were created by hatching and then rubbing with a damp finger. The contrasting light areas of the deciduous tree were created by dabbing with a wet finger.

Artist's Tip

Always be well prepared when you go sketching outdoors in less than ideal conditions. In addition to your usual kit, take drawing pins, something to sit on and waterproof clothing.

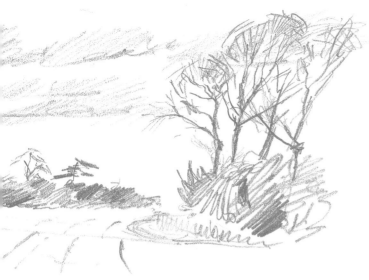

Rapid sketching

The most atmospheric drawings are often those done in less than ideal weather conditions when you are forced to sketch quickly and without recourse to constant measuring. An advantage of rapid sketching is that it forces you to rely on your senses. Thinking before you commit a view to paper is recommended, but the actual execution needs to be speedy and fluent if the immediacy of the scene is to be captured.

This rapid charcoal sketch of an oak tree *(below)* alongside a lane was drawn as storm clouds hurried across the sky. I used it as a basis for an oil painting.

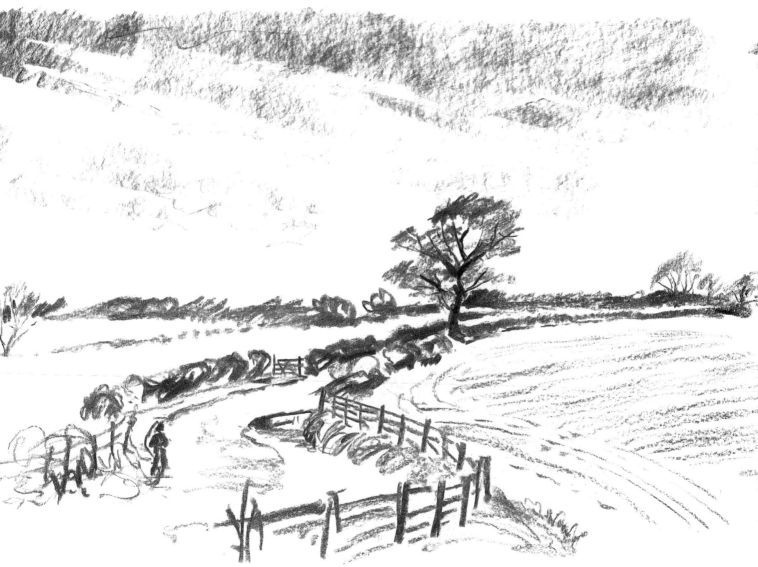

Trees and Landscape

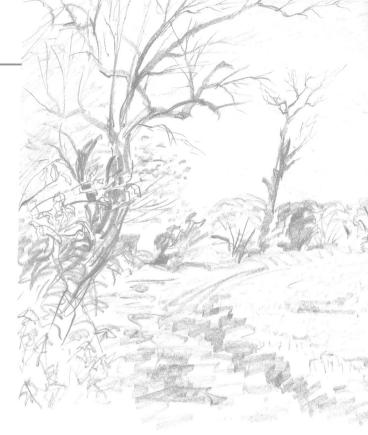

A tree may be the dominant element in your picture, but to present it as a solitary object in a sea of white paper is to reduce its scale and stature. You can establish its size by including some of its surroundings; even a small area of the tree's shadow will serve this purpose. Quite often in my drawings I introduce a couple of people to provide scale, although they may not have actually been there at the time. It is a good idea to include a distant feature, such as a hedgerow or group of houses, to help place your tree in the context of its own environment.

Both trees and other landmarks will obey the rules of linear and aerial perspective (see pages 44-7).

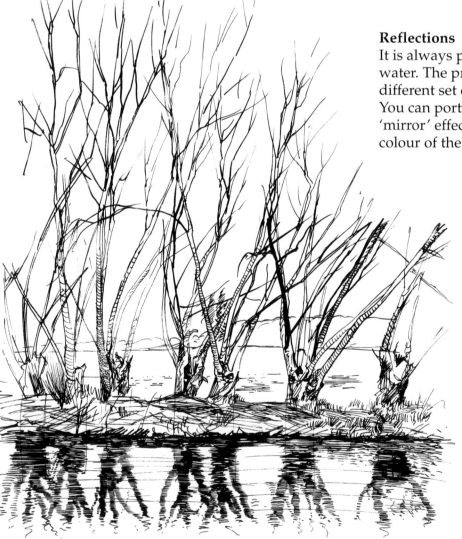

Reflections

It is always pleasant to sit and draw beside water. The presence of water in a scene offers a different set of opportunities for depicting trees. You can portray, for example, the distorting 'mirror' effect of vegetation and the light and colour of the sky as reflected in the water.

I drew this group of pollarded willows lining the bank of a river because I wanted to show the way the branches overlapped, the pattern of negative shapes and the type of reflection these elements made in the still water. I used a fibre-tipped fountain pen.

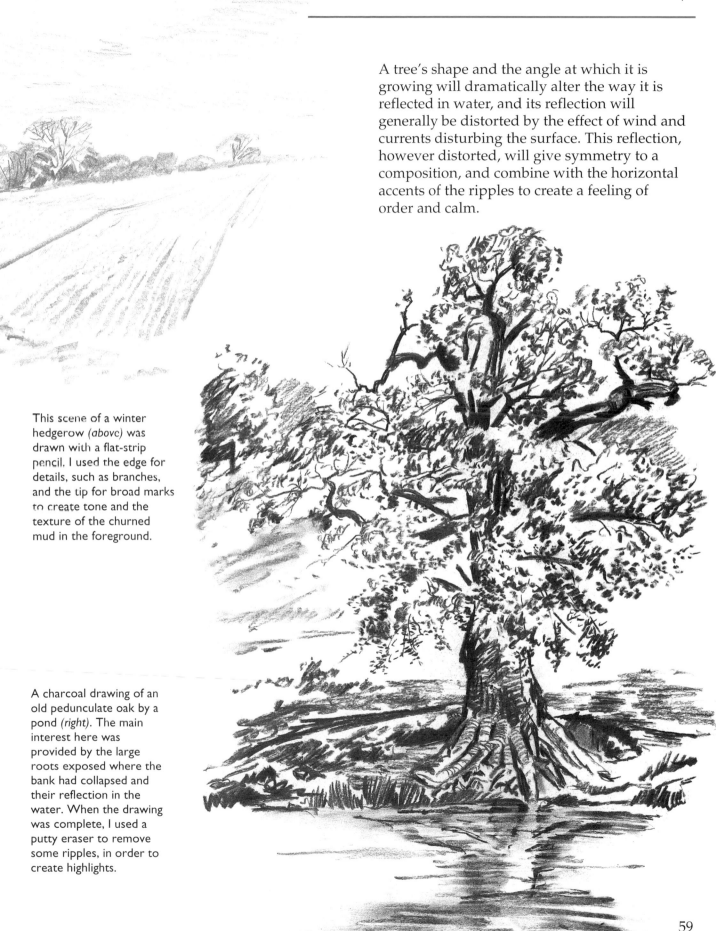

A tree's shape and the angle at which it is growing will dramatically alter the way it is reflected in water, and its reflection will generally be distorted by the effect of wind and currents disturbing the surface. This reflection, however distorted, will give symmetry to a composition, and combine with the horizontal accents of the ripples to create a feeling of order and calm.

This scene of a winter hedgerow *(above)* was drawn with a flat-strip pencil. I used the edge for details, such as branches, and the tip for broad marks to create tone and the texture of the churned mud in the foreground.

A charcoal drawing of an old pedunculate oak by a pond *(right)*. The main interest here was provided by the large roots exposed where the bank had collapsed and their reflection in the water. When the drawing was complete, I used a putty eraser to remove some ripples, in order to create highlights.

59

Trees and Buildings

Trees and buildings can lend a sense of scale to one another and evoke a strong sense of place. Trees can dominate buildings or complement them by tempering their hard angularity with the fluid, softer texture of their leaves.
Drawing buildings is easier to accomplish if you think of them in terms of simple shapes, such as boxes, cylinders, wedges and cones. Remember that, like trees, buildings follow the rules of linear perspective. You can make their flat surfaces look more interesting by giving an indication of surface texture, for example, brick, stone, tiles or glass. Do not overdo it, however, because an all-over wallpaper finish would be both boring and serve to unbalance the composition. Always try to give an indication of texture that is just sufficient to suggest the form of the building.

The right balance

The balance between tree and building needs to be carefully considered. Only one or other of them should dominate texturally or tonally. If there is too much detail in both, the picture can easily end up looking overworked. Tonal domination is not necessarily a reference to the darkest or lightest area of the sketch. The centre of interest can dominate by just having the widest variation or range of tone.

The attenuated shape of the tree dominates in this composition, towering over the buildings in the background. The lamp posts echo the vertical emphasis of the tree.

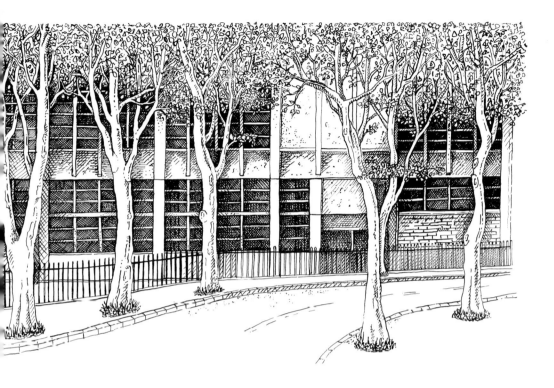

Tonally the building dominates here, the trees appearing as white shapes against the dark windows *(left)*. The loose shape of the trees and leaves contrasts with the grid of the building.

The cinema in this drawing could be virtually anywhere, but for the presence of the palms which tell us that it must be somewhere warm *(below)*. Although not the main centre of interest, the tree is an integral part of the drawing, providing a visual frame for the building behind.

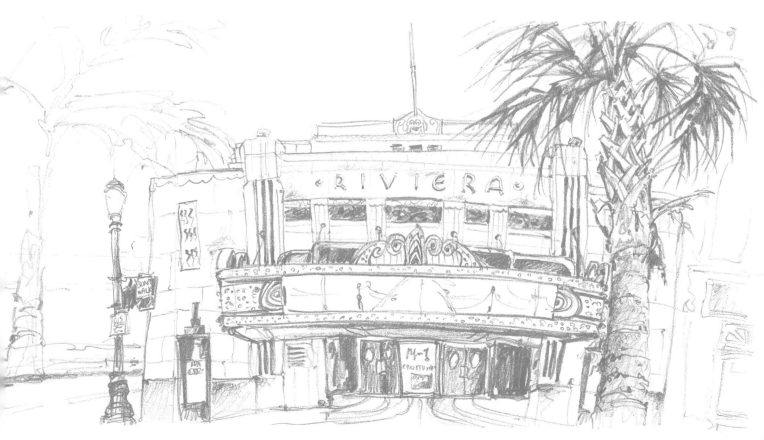

Working from Photos

Photographs can be used to supplement sketches or as an inspiration for pictures in their own right. When drawing trees from photographs it is particularly important to appreciate their three-dimensional structure. Allow yourself time when taking your own photographs for reference to walk around the tree and study it from different angles. You will notice that the arrangement of the branches changes with the point of view. Taking a picture from a low viewpoint, framing the tree against the sky or using a shallow depth of field to throw the background out of focus can all be useful techniques.

When you come to start your drawing, recall the spatial relationships that pertained when you took the picture. Always include visual clues,

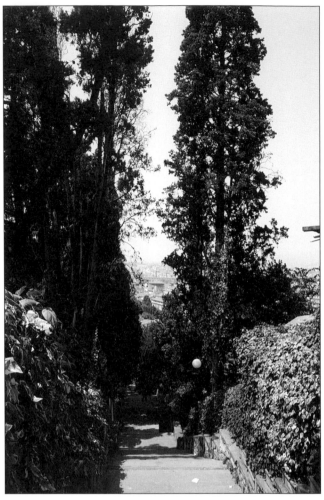

You can easily 'freeze-frame' a tree shown on video and quickly sketch it, as I have done here *(left)*.

This transparency *(above)* was used as the basis for the finished pastel drawing opposite.

such as the shadow of one branch falling across another, to help describe the form of the tree. Be aware of the pattern of light and dark in the photographs and when working on the page use tone, not outline. Take as many pictures as possible from several angles as you may change your mind about what interested you by the time you come to draw the tree.

You can also experiment with re-composing magazine photographs, deciding on what would make the best picture and then isolating the part you need.

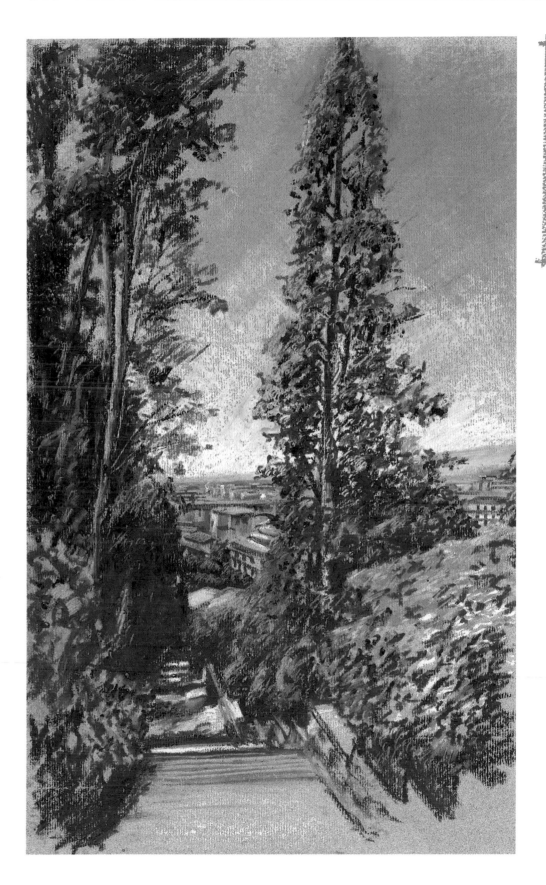

Artist's Tip

When using other people's photographs, avoid simply repeating their viewpoint. Use only part of their picture as a basis for your drawing, thus enabling you to make your own individual statement about the subject.

This drawing in oil pastel on blue paper was developed from the transparency shown on the opposite page. The texture afforded by the oil pastel was ideal for making bold textural marks to suggest the foliage of the cypress tree on the right. I built up the colour in layers and used a scalpel to scrape out crisp shapes to represent the city in the distance. I made a feature of the shadow on the steps.

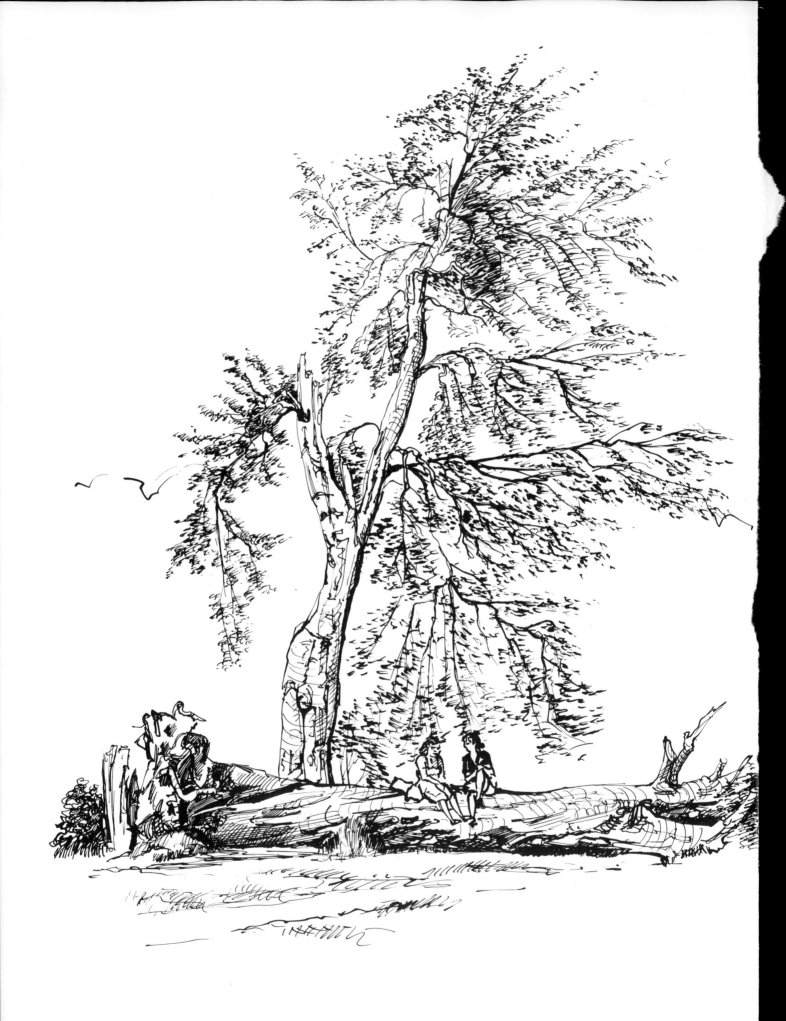